The Ruby-Throated Hummingbird

...

A Photo Essay

by James B. Sumpter

Thanks to Maggie

All photos by James B. Sumpter

Copyright 2018

by James B. Sumpter

ISBN 978-0-578-42503-0

Each spring, since 2012, I've set out feeders to attract Ruby-throated Hummingbirds. They arrive each year on their return migration from Central America. They will spend their spring and summer in the central and eastern United States up into Canada. It is at this time that they produce new broods of offspring.

As a result, I've had the opportunity to observe and learn about them, which includes being able to recognize the zooming buzz of their wings and their lively chirps. Observing the hummingbirds has been satisfying and entertaining. However, when I started photographing them, I discovered how much I was missing.

The human eye can't see much of a moving hummingbird. In-flight, its black wings are virtually invisible. That's because when in-flight (or hovering) the hummingbird's wings beat between 55 and 80 times a second, and its normal flight speed is 37 feet per second (25 mph). Also, you won't see much of its detail, due to its small size and quick movements. Fortunately, the splendor and detail of a hummingbird can be viewed with the aid of a quality camera body, a good lens, the right settings and a little luck.

On the following pages are 88 full-page sized photographs that show the Ruby-throated Hummingbird in great detail. They show the hummingbird from numerous perspectives and they capture the many variations in its appearance. In addition, some photos catch the humming bird in mid-flight, thereby "freezing" its wings. Others show the Ruby-throated Hummingbird's green and gold iridescent colors, its black beak, its white tongue and its black wing feathers. Several photos capture the various iridescent colors (red, gold and black) of the male's throat feathers (the gorget - pronounced (/ˈgôrjət/). These colors are dependent on the angle of reflected light.

A number of photos show females and adolescent males who are partly distinguished by the white tips on six of their tail feathers (three on either side). The adolescent male can be further distinguished by the dark streaks and/or a small fleck of red feathers on his throat. Other photos show the female clutching clumps of spiderweb that she will use in constructing her nest. And, some photos show the birds open beak, while others show it extending its long tongue.

Many photos show the Ruby-throated Hummingbird roosting or feeding at a feeder, which is holding a sugar-water mix. Others show the

hummingbird feeding on the real thing, flower nectar. Still, other photos capture the territorial nature of the humming bird, as they show dramatic slices of "feeder wars."

Thus, I'm proud to provide these photos in this coffee-table book and I anticipate your joy and excitement in discovering the not so visible aspects of the Ruby-throated Hummingbird.

— James B. Sumpter

References:
http://www.rubythroat.org,
Birds of Indiana field guide by Stan Tekiela
www.birdwatchersdigest.com/bwdsite/learn/hummingbirds/faqs.php
https://theiwrc.org/kids/Facts/Birds/rubyhum1.htm
www.allaboutbirds.org/guide/Ruby-hroated_Hummingbird/lifehistory
www.audubon.org/field-guide/bird/ruby-throated-hummingbird
https://en.wikipedia.org/wiki/Hummingbird

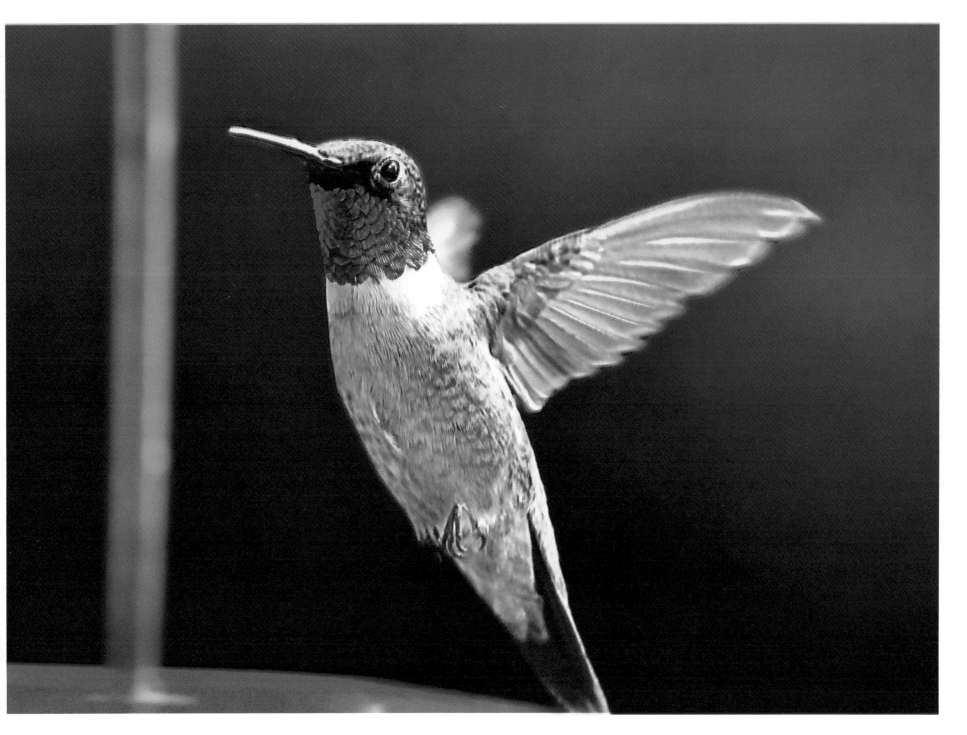

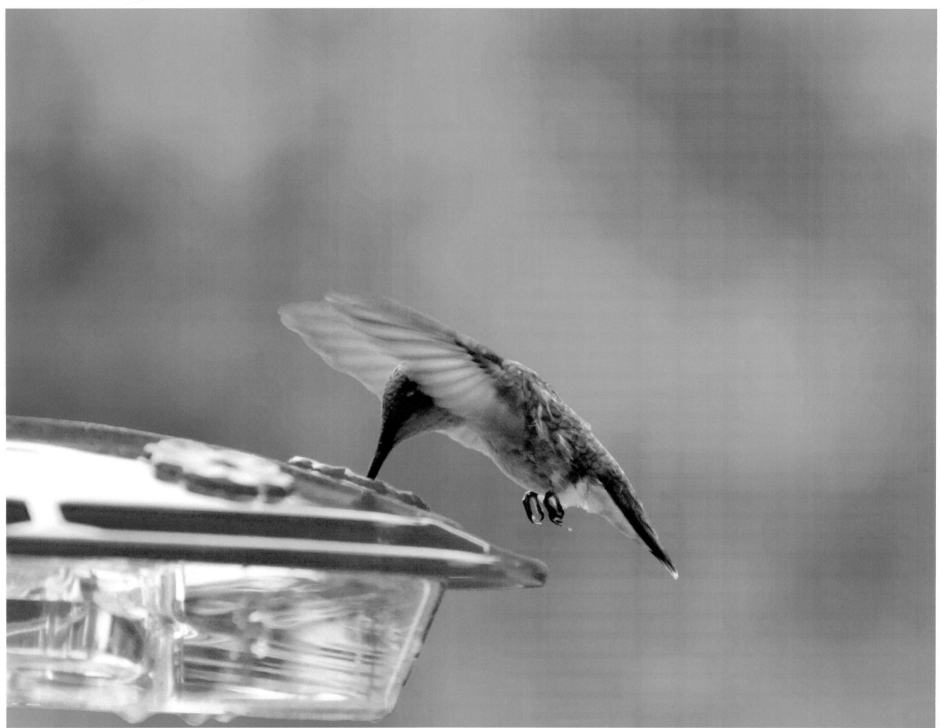

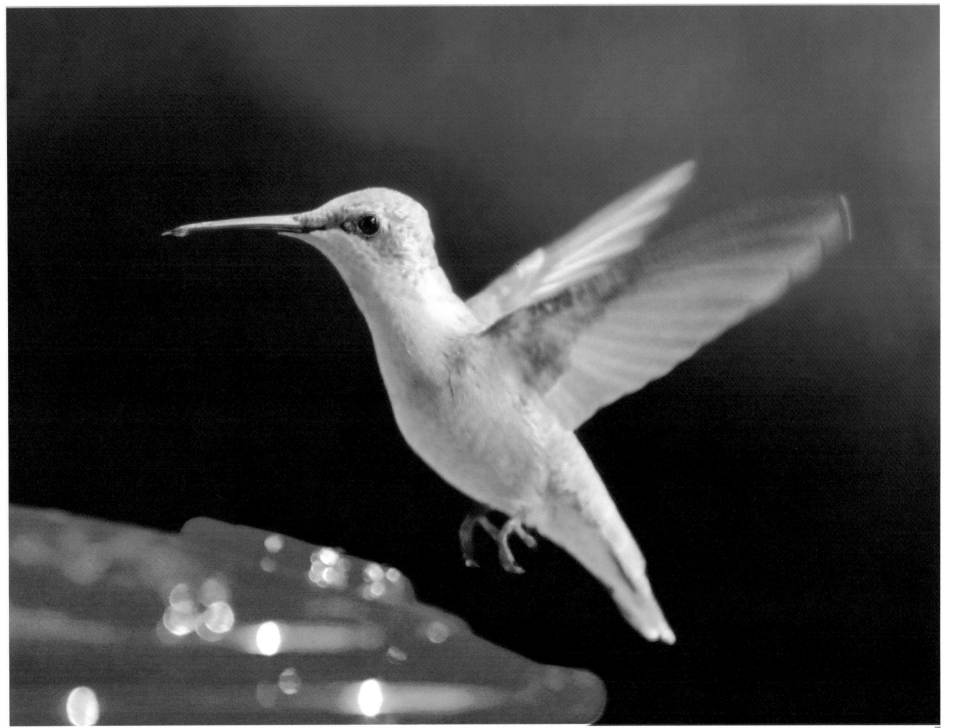

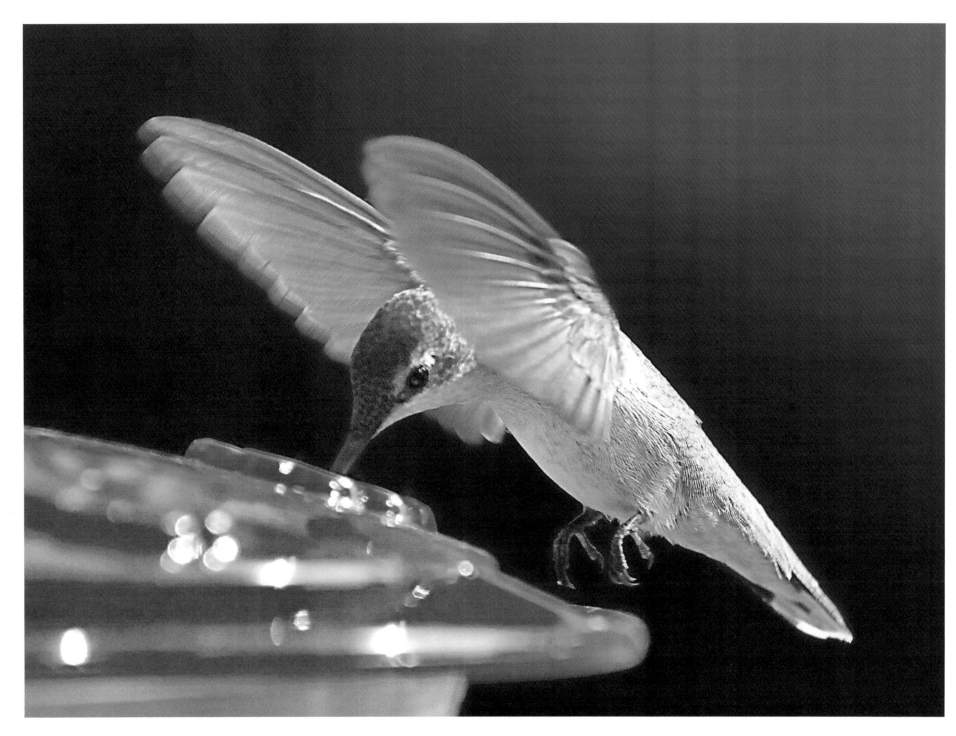

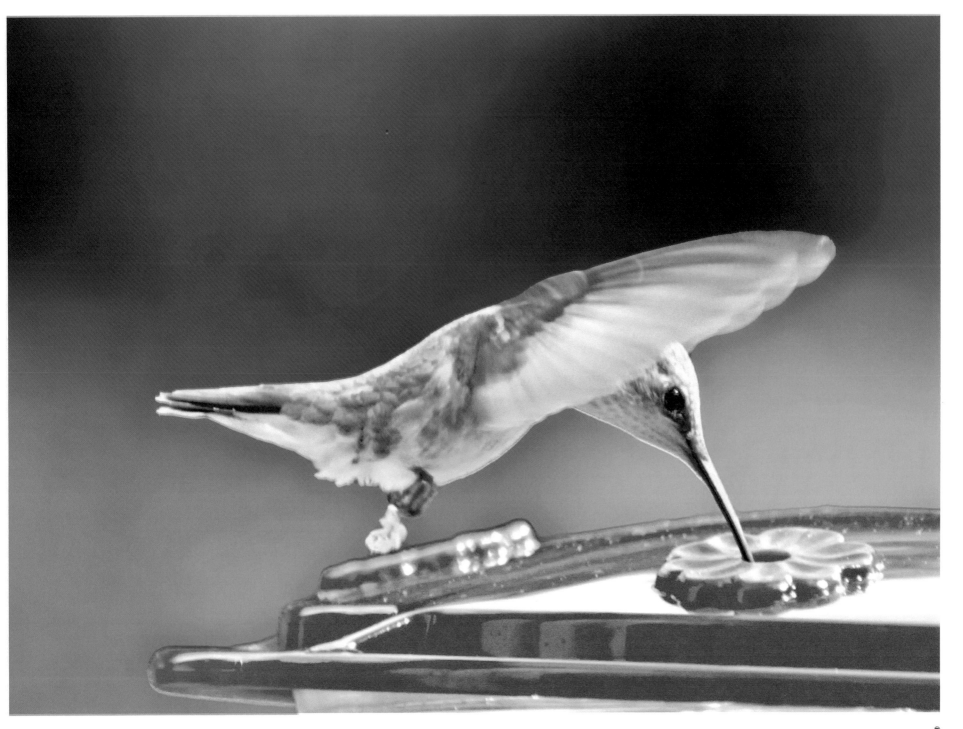

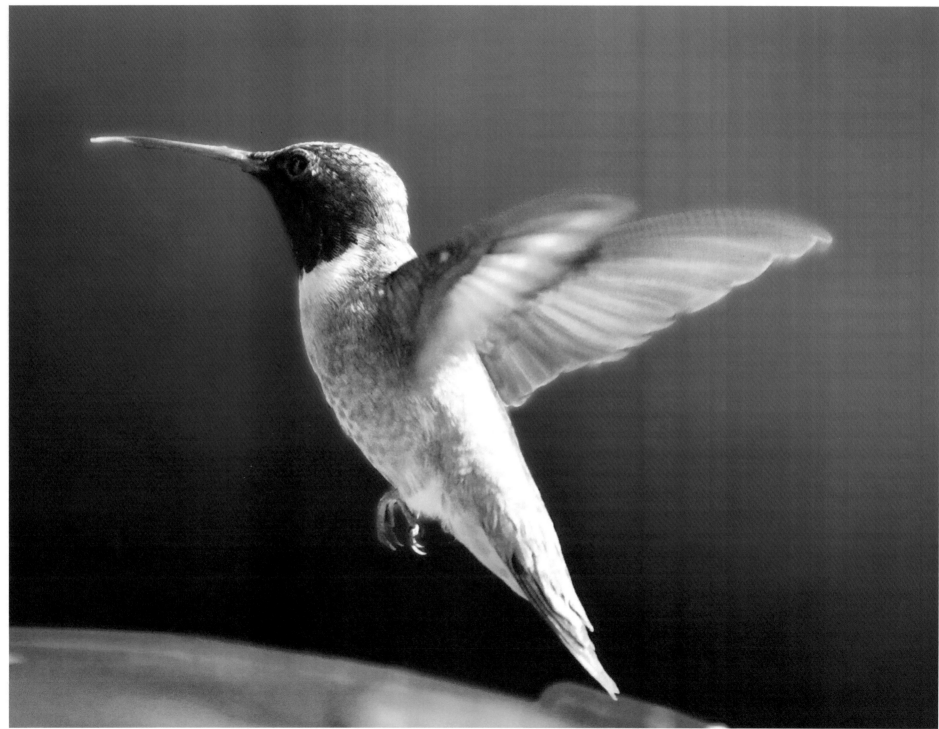

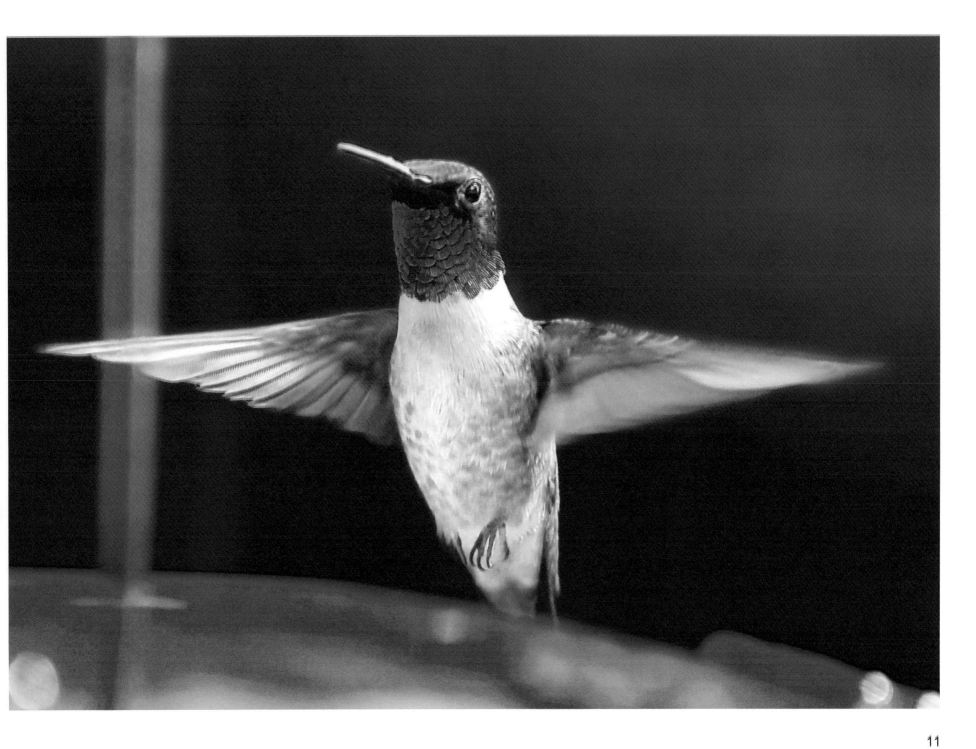

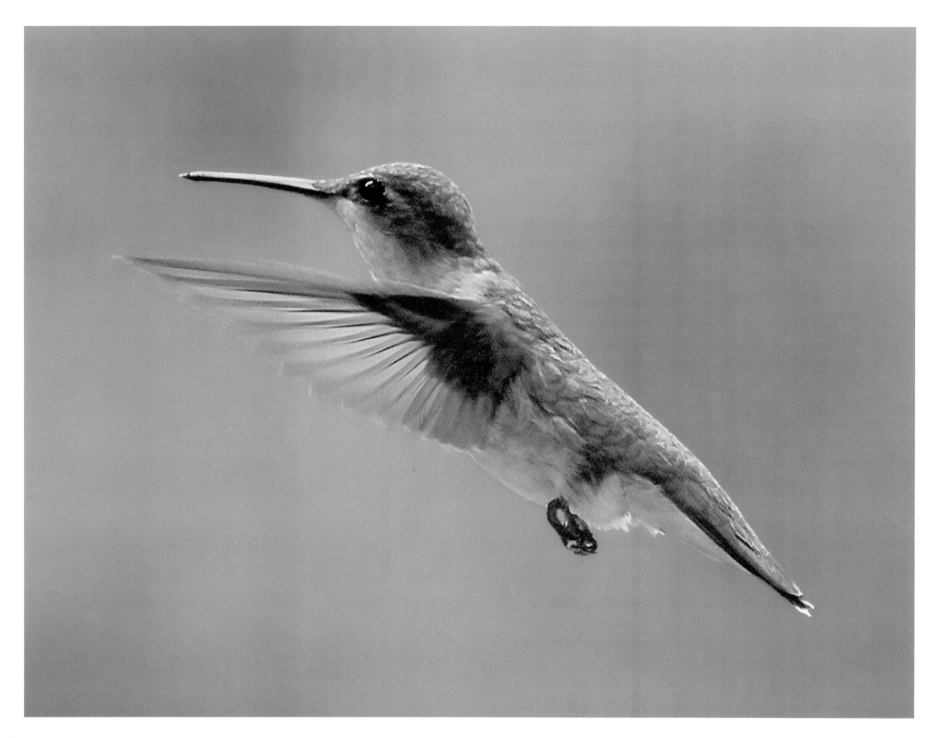

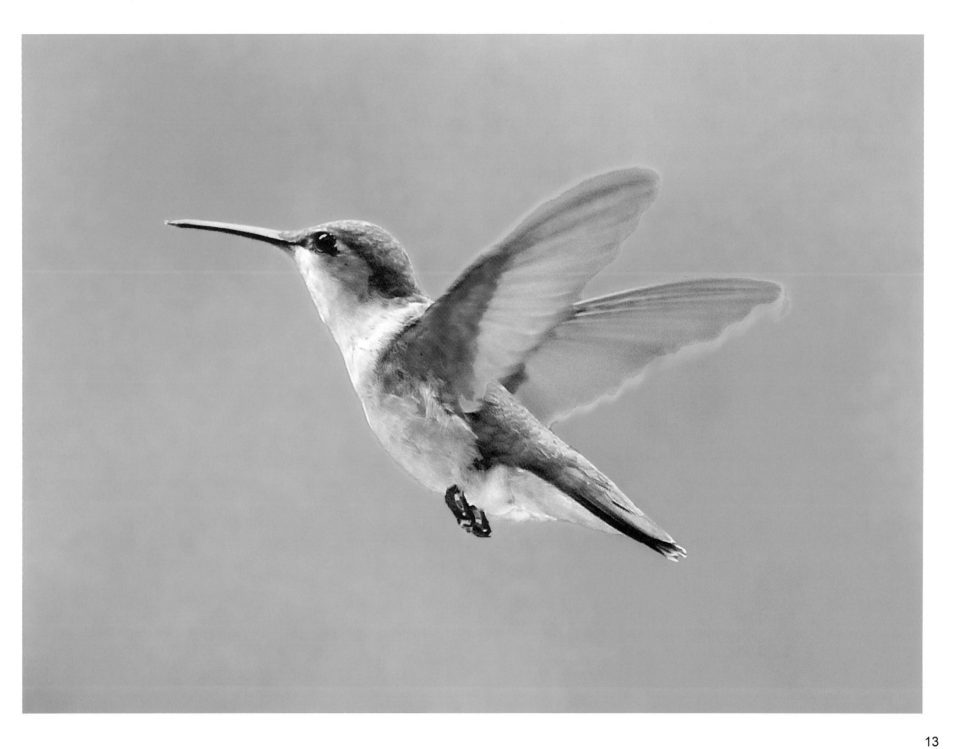

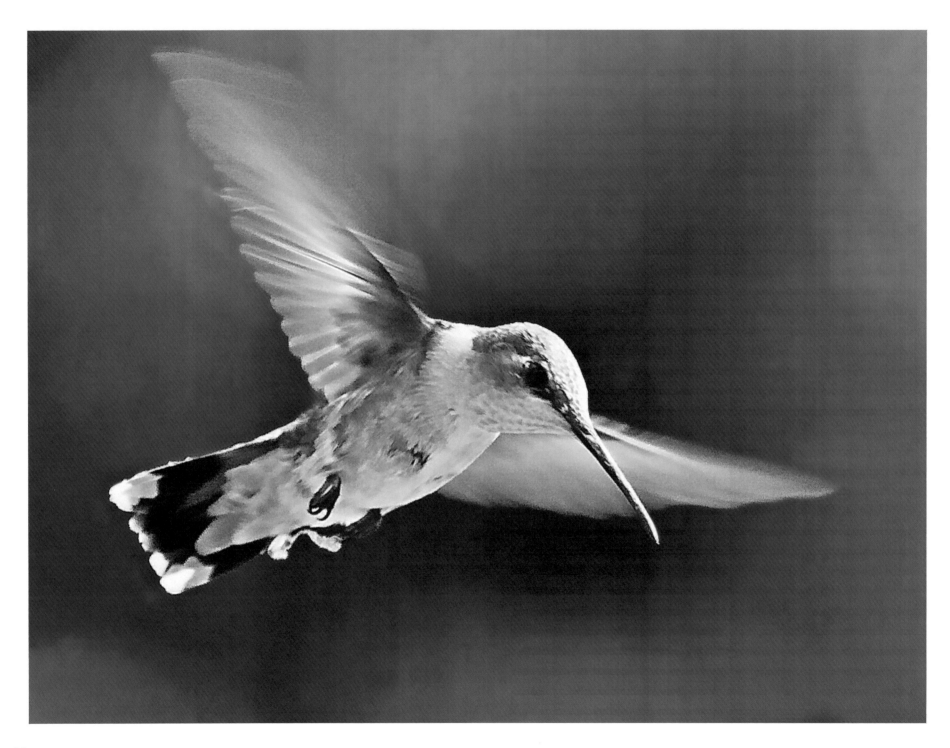

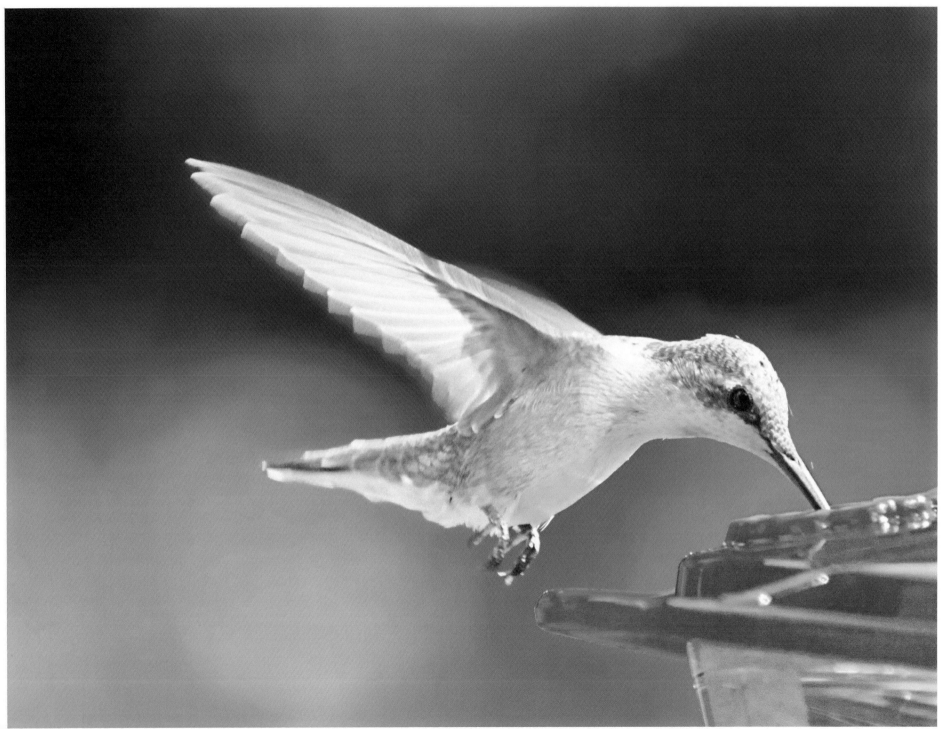

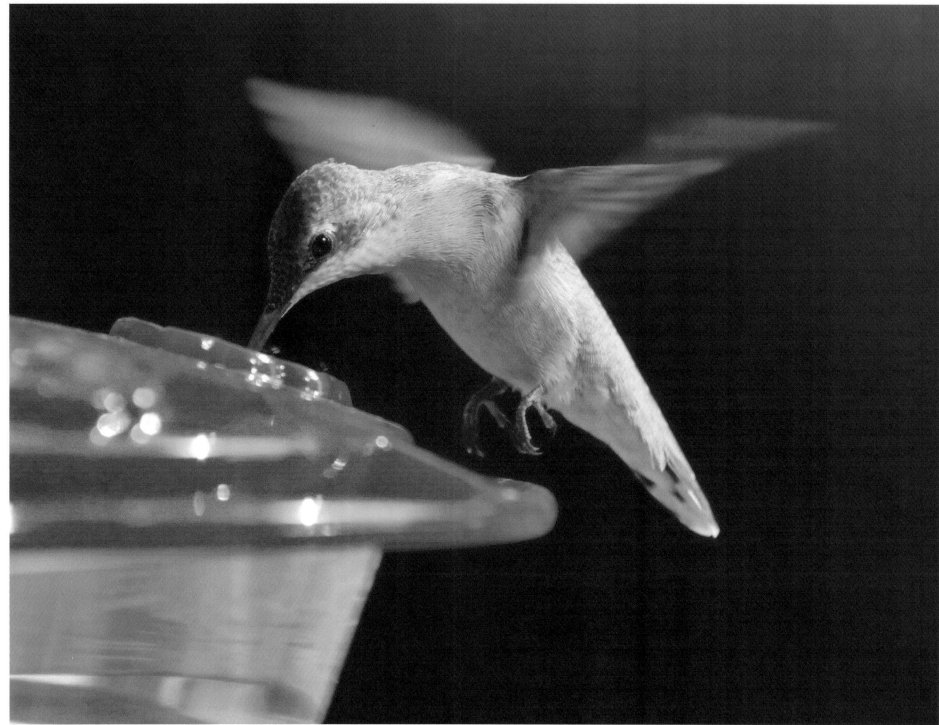

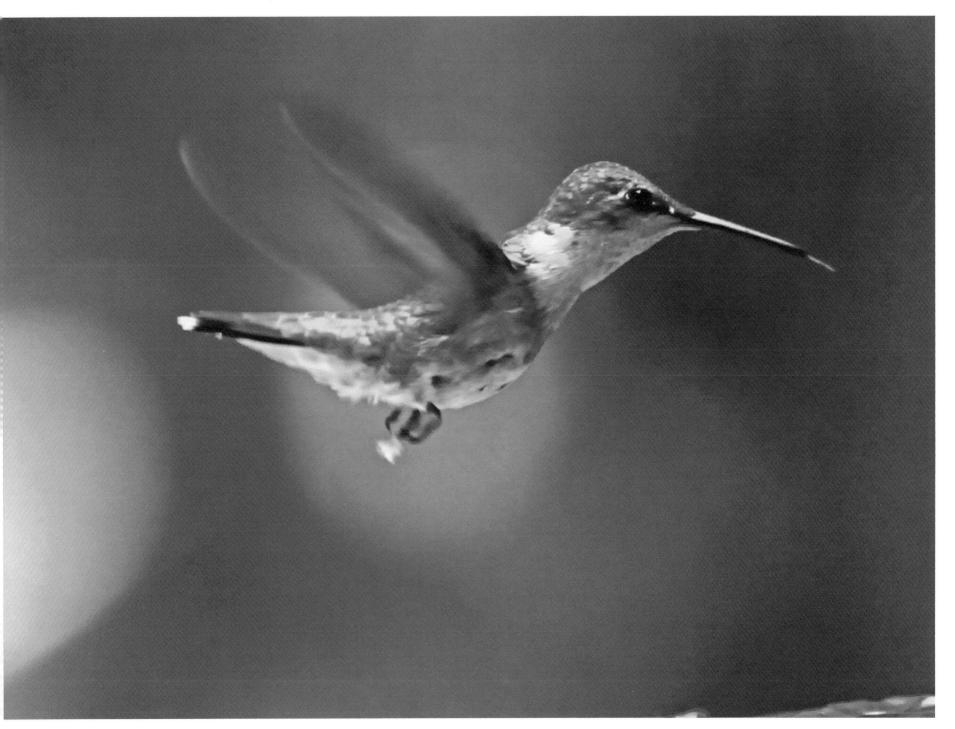

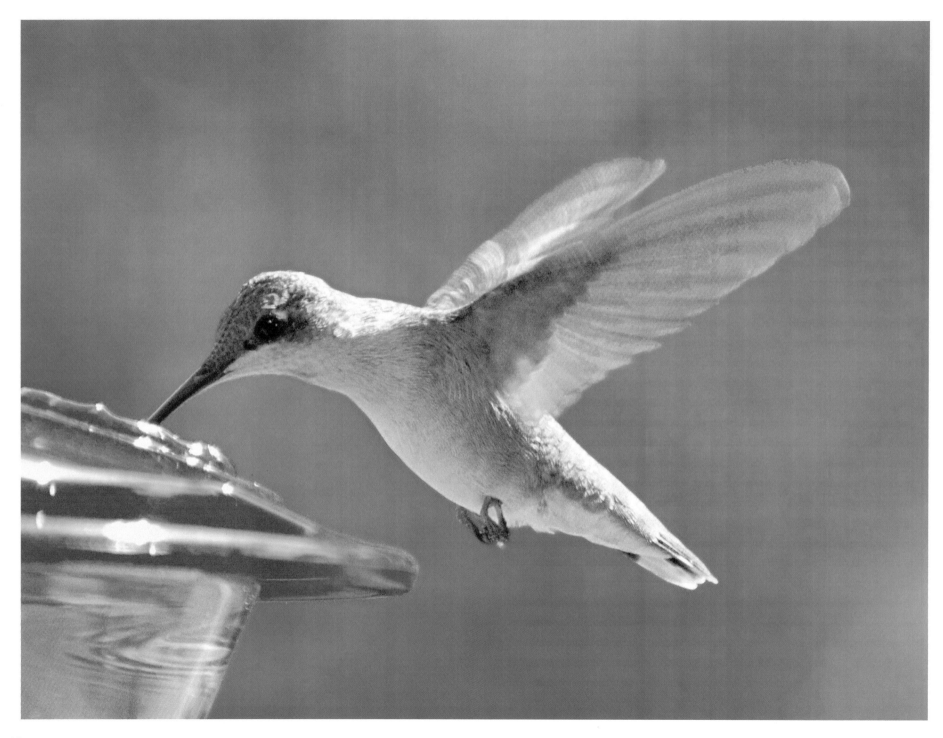

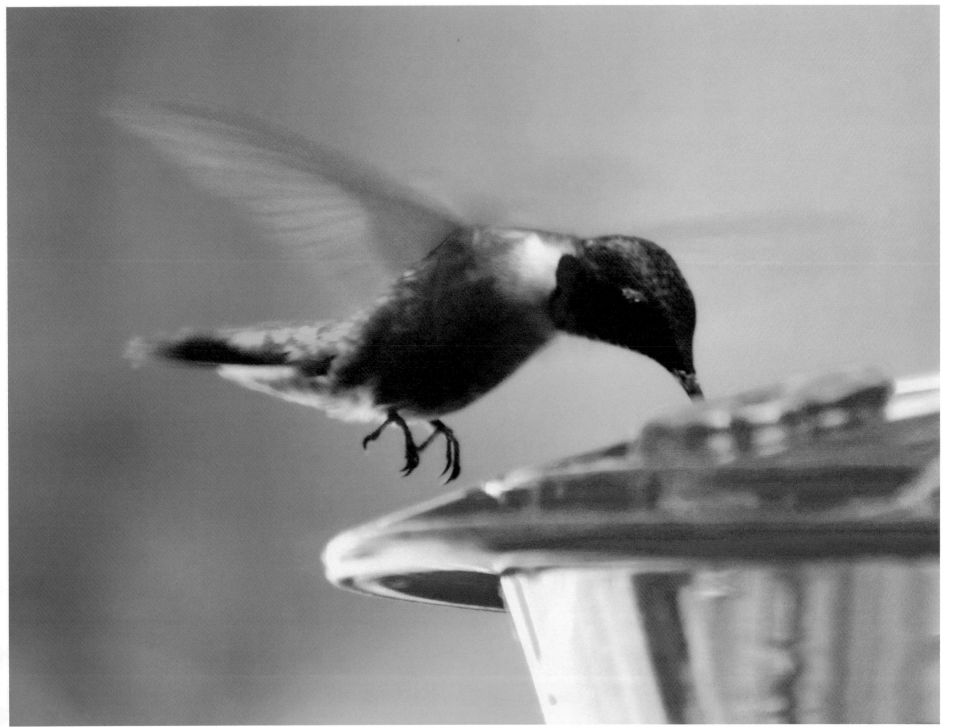

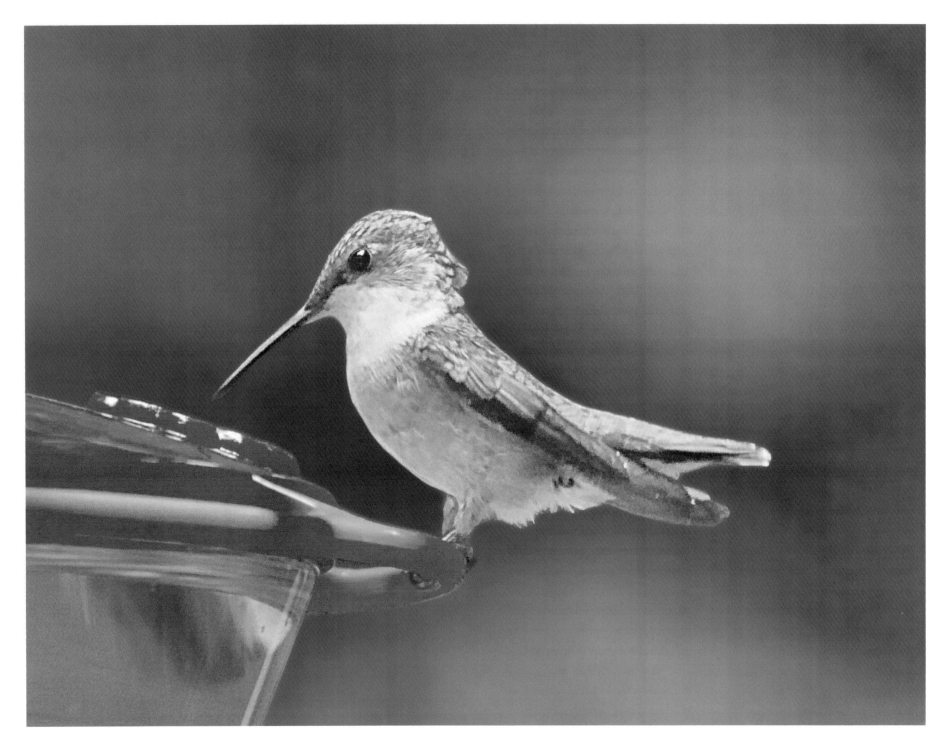

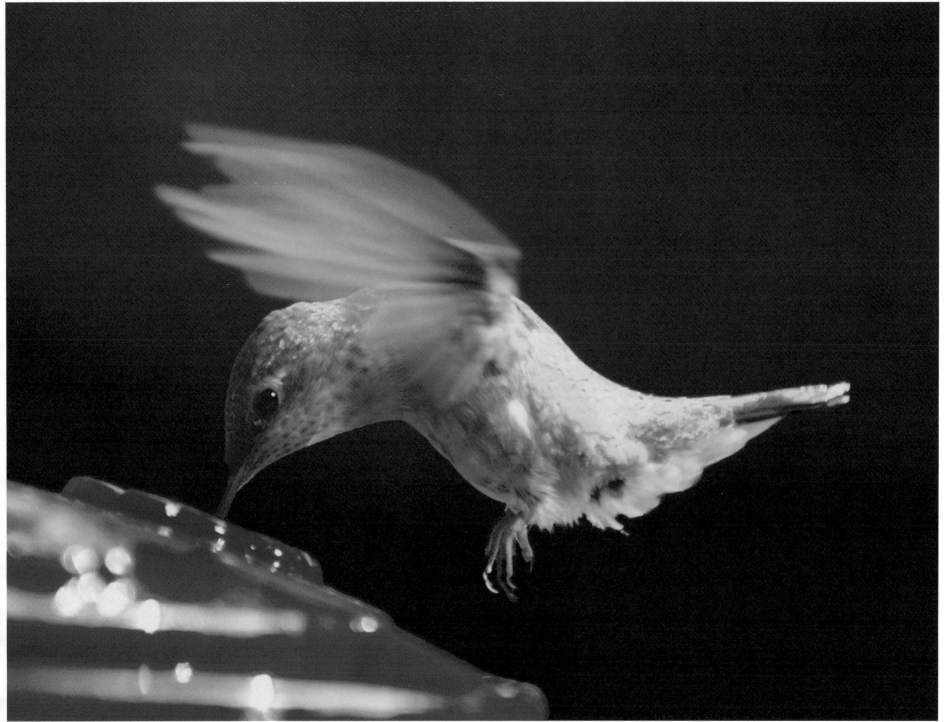

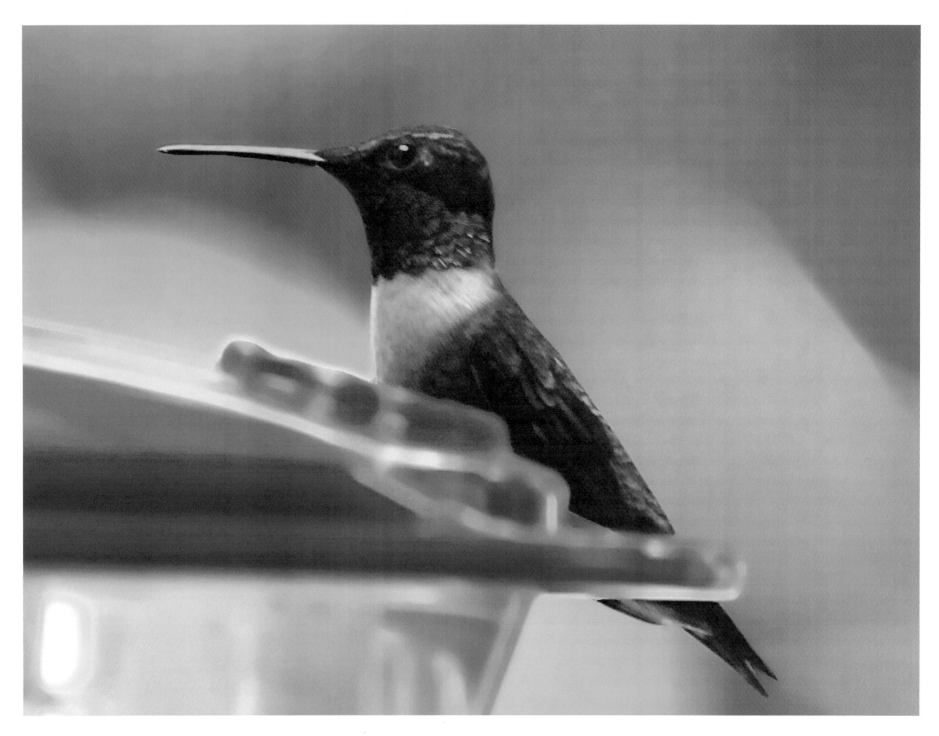

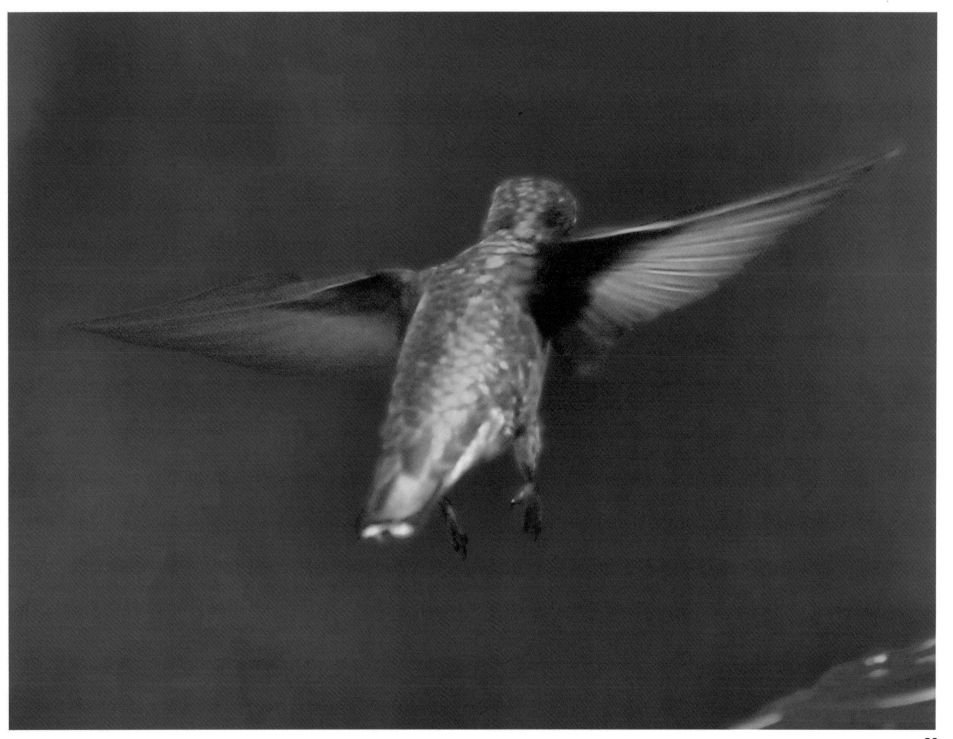

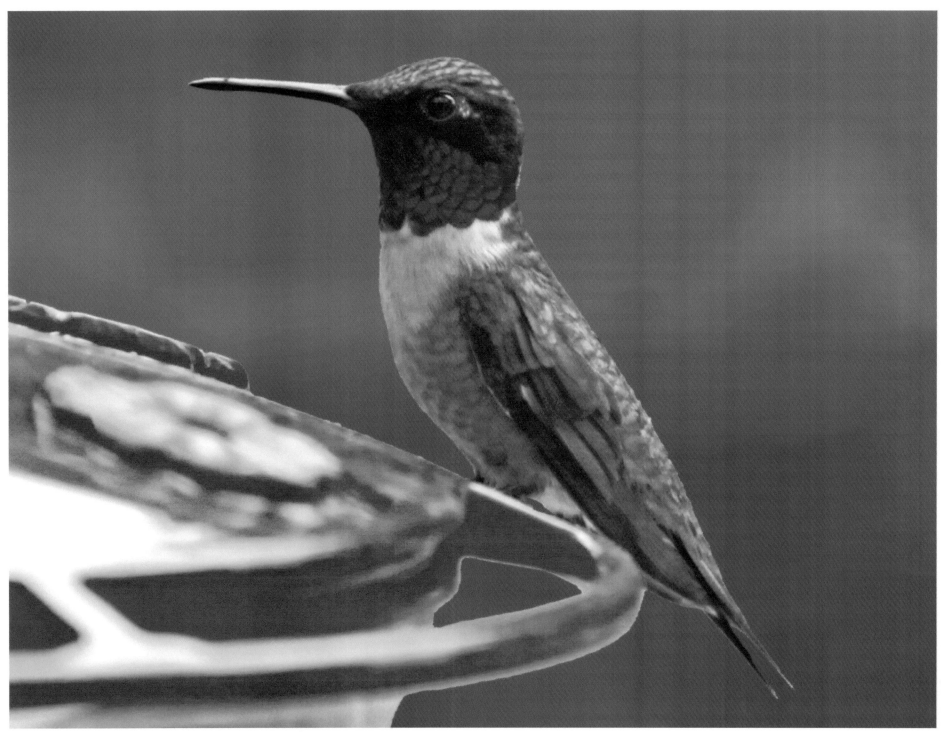

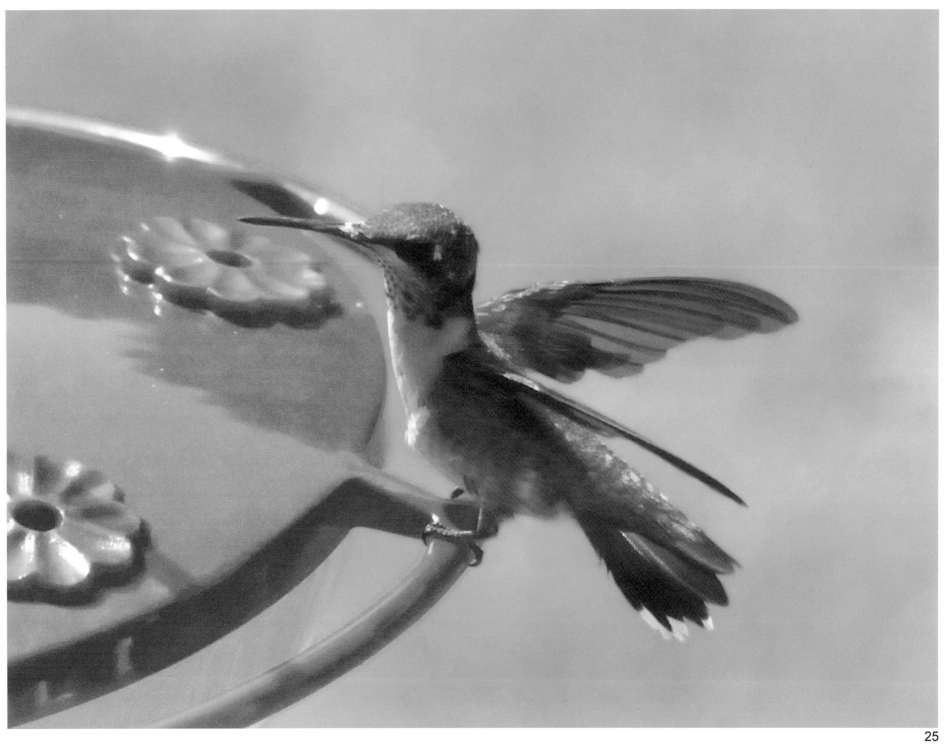

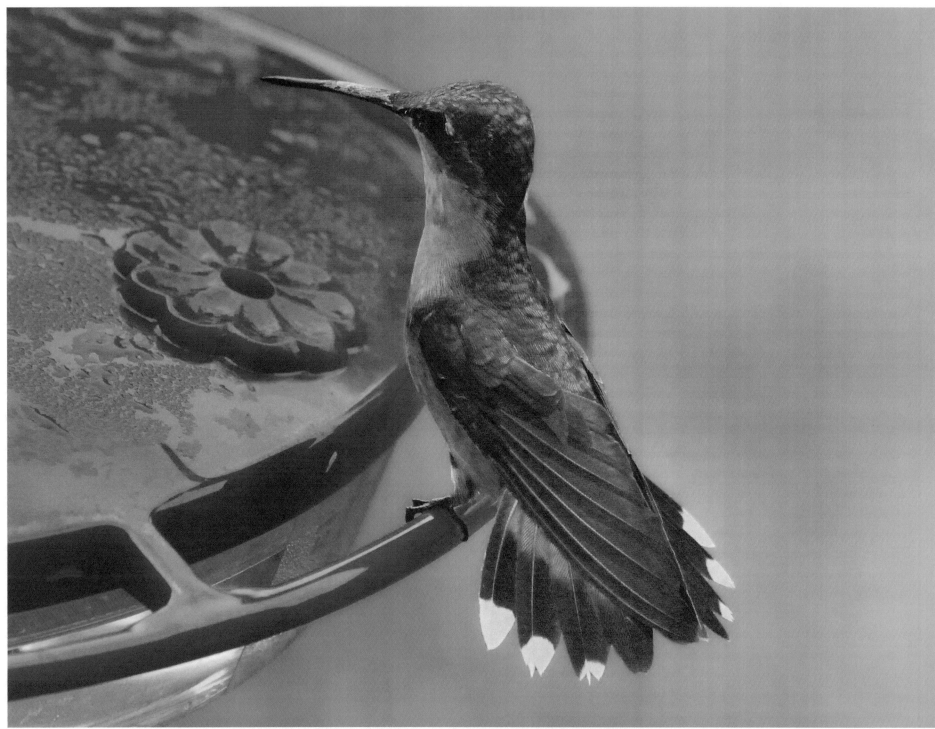

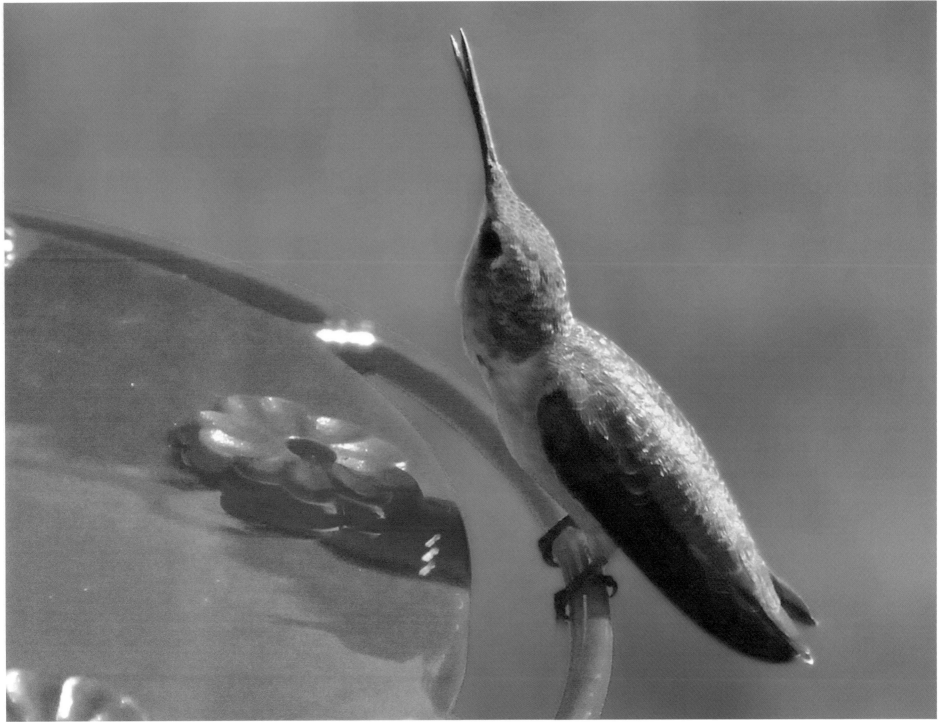

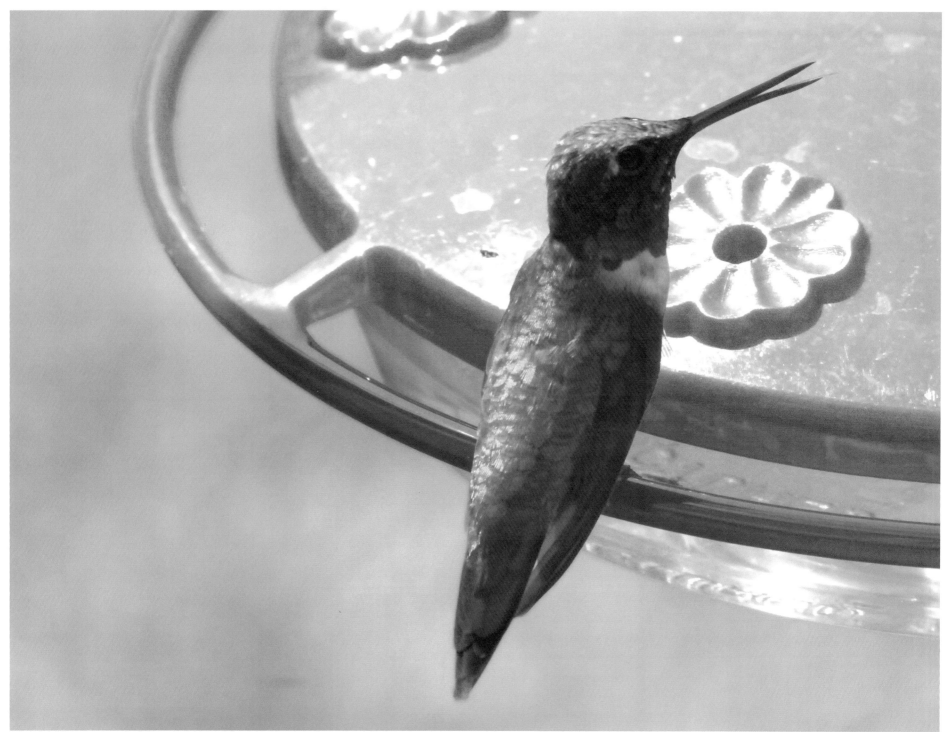

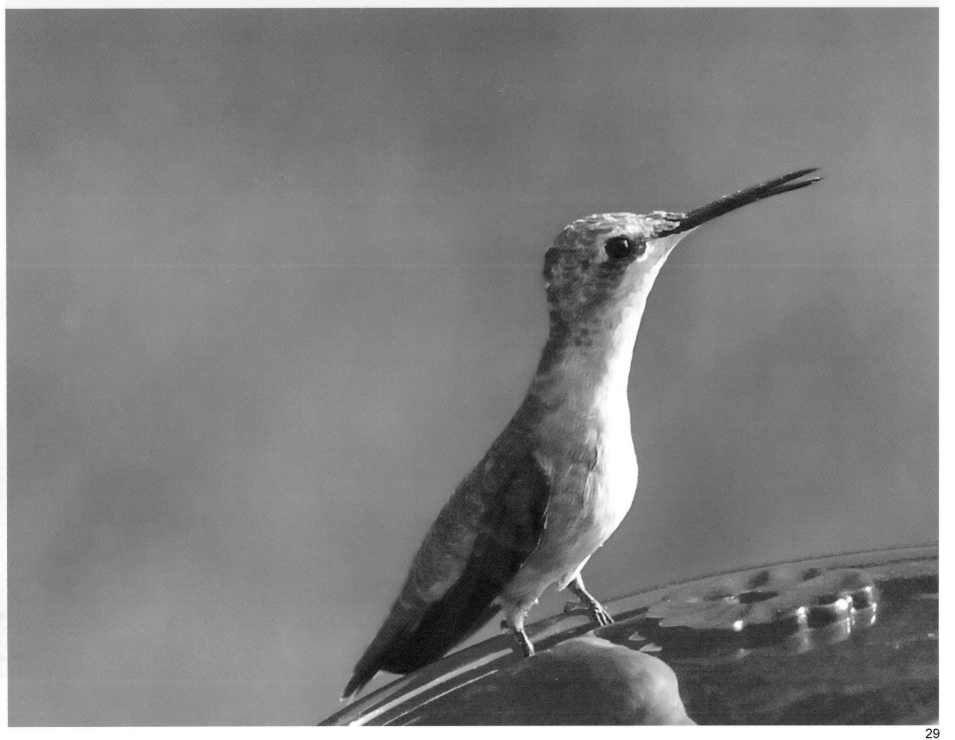

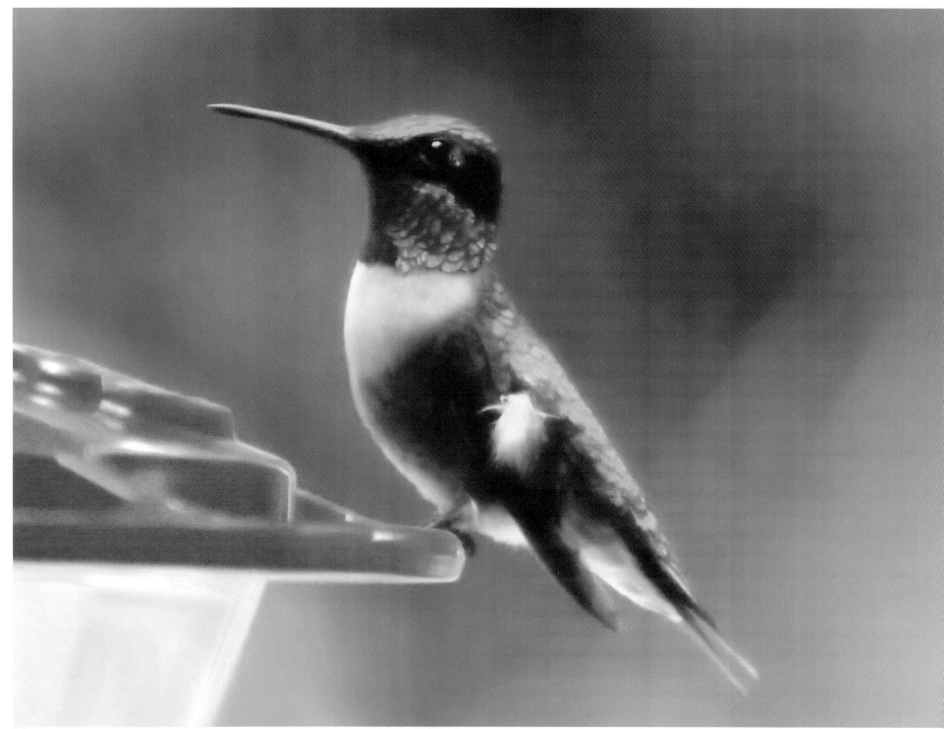

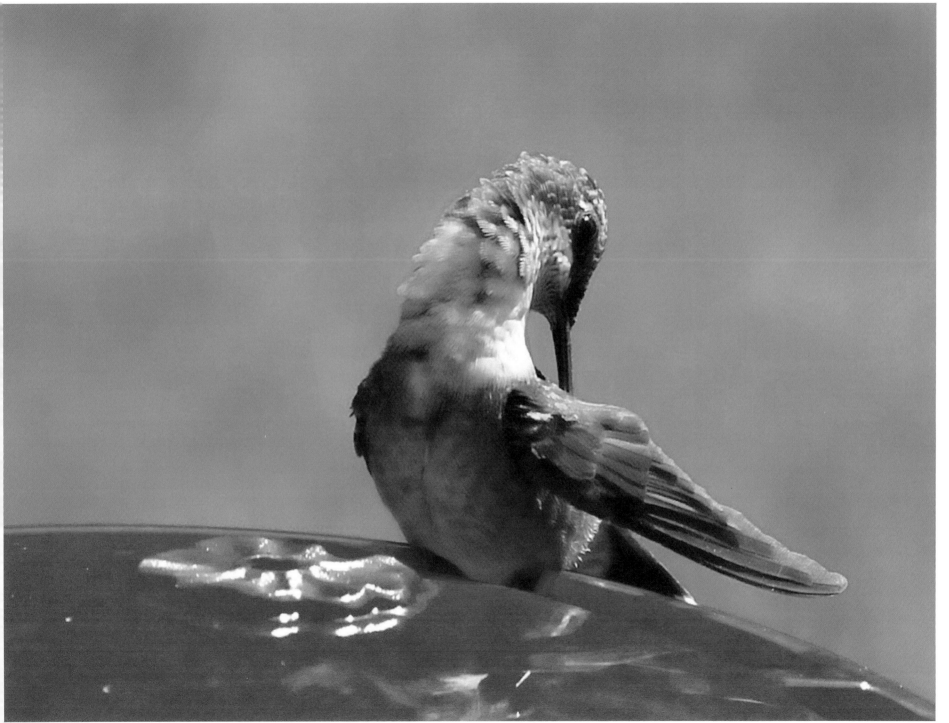

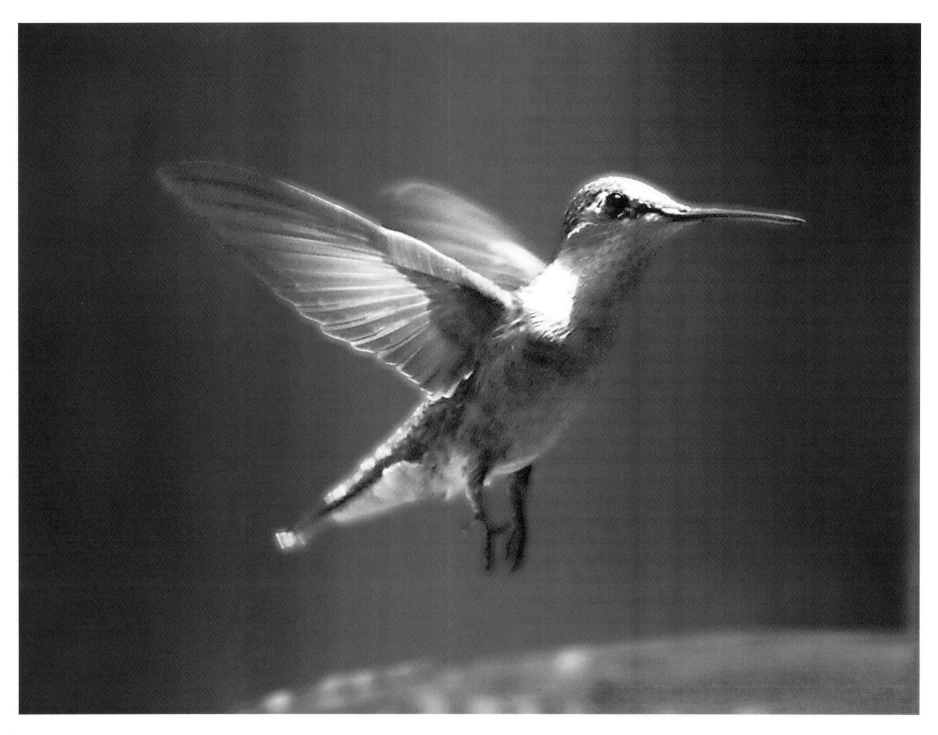

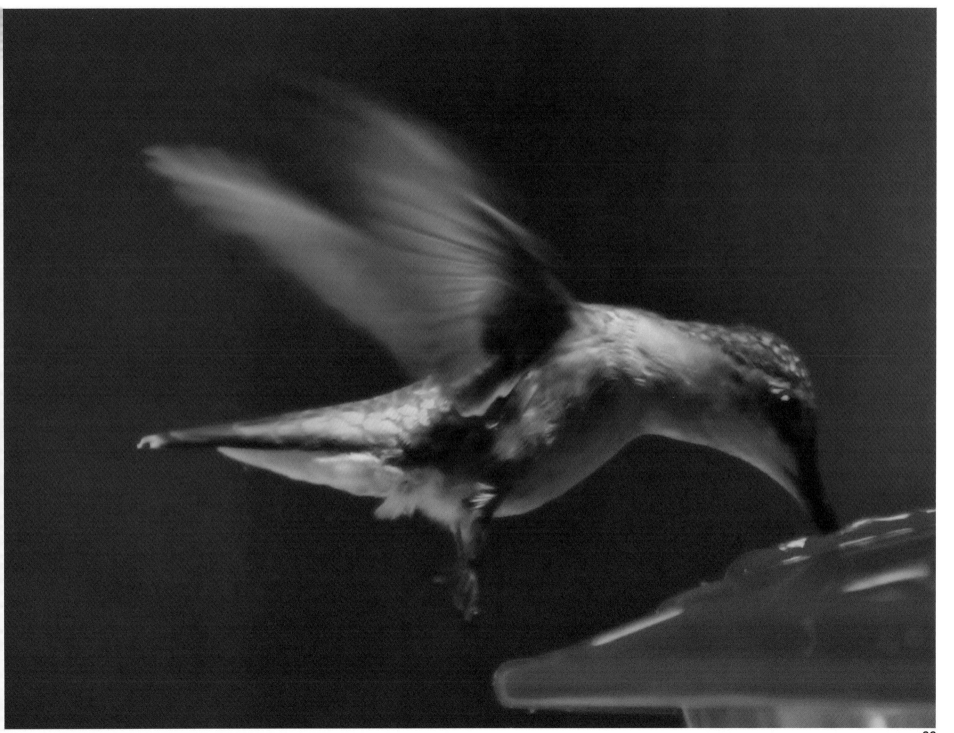

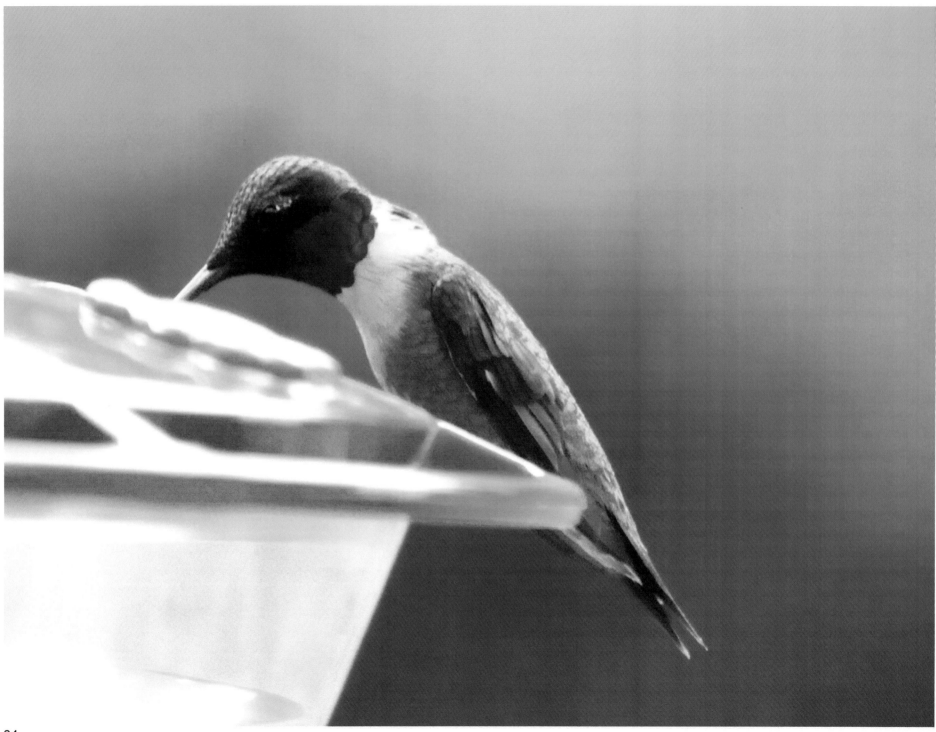

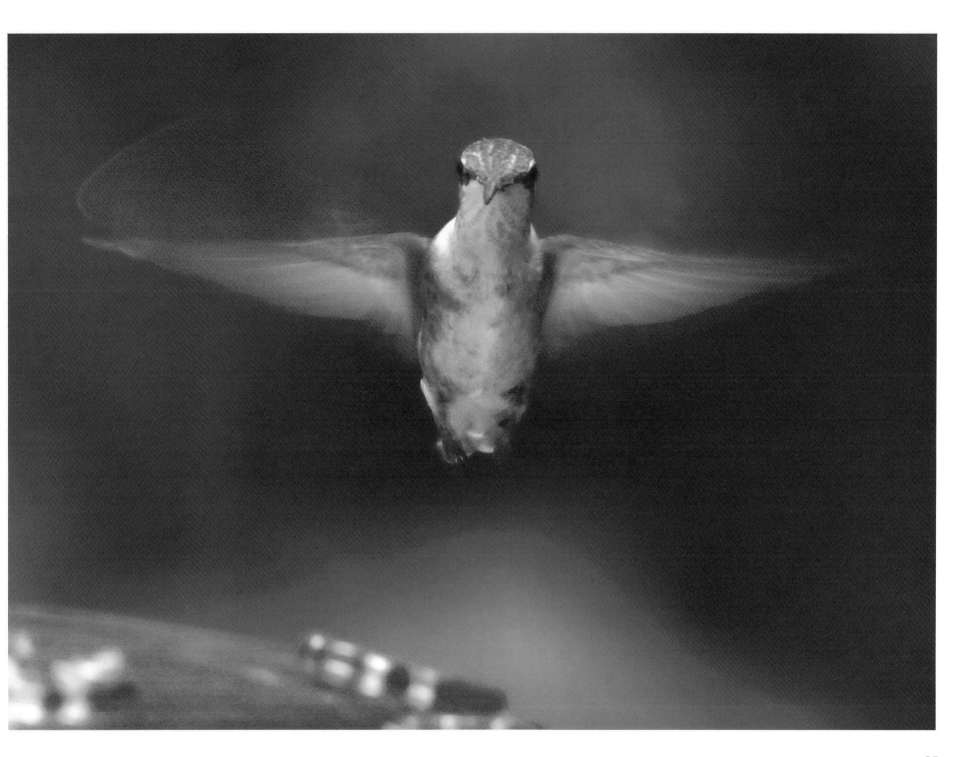

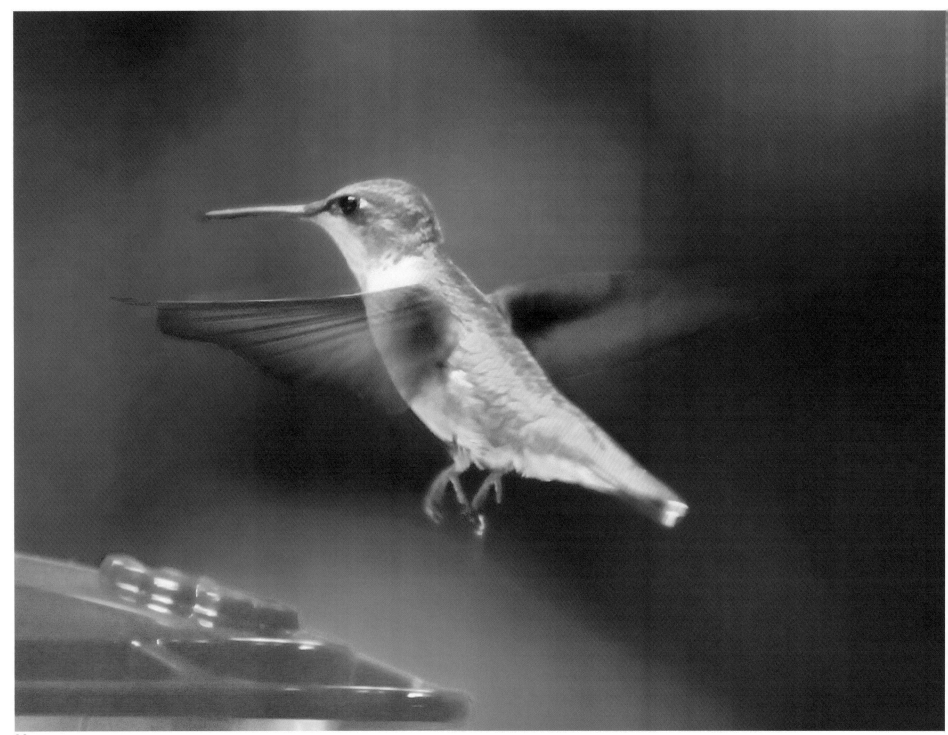

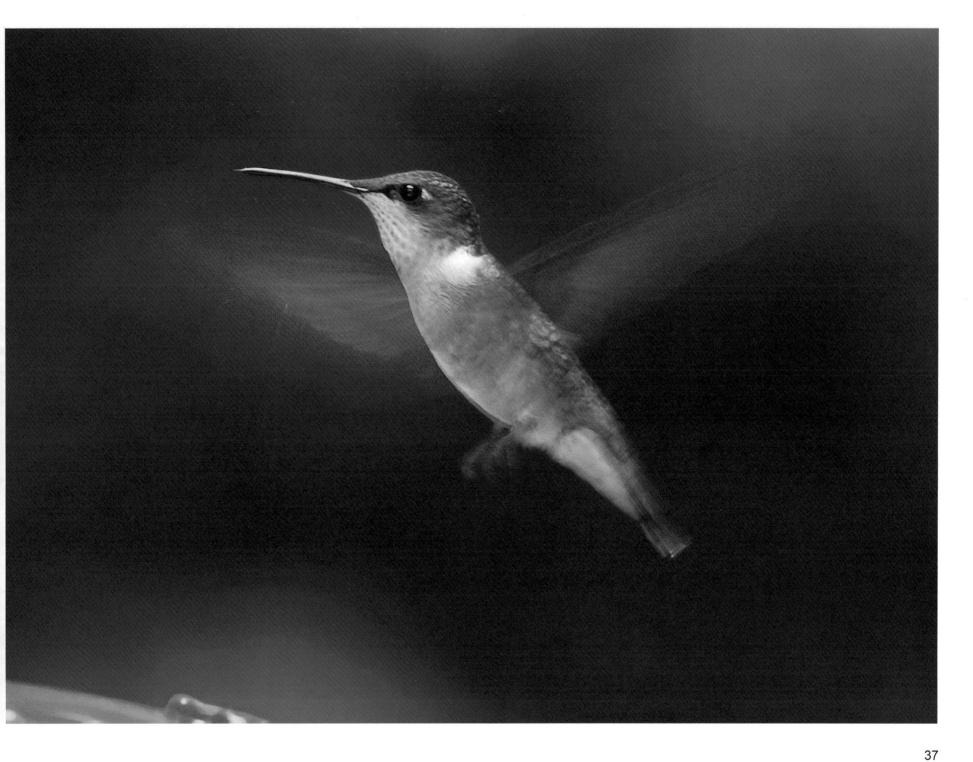

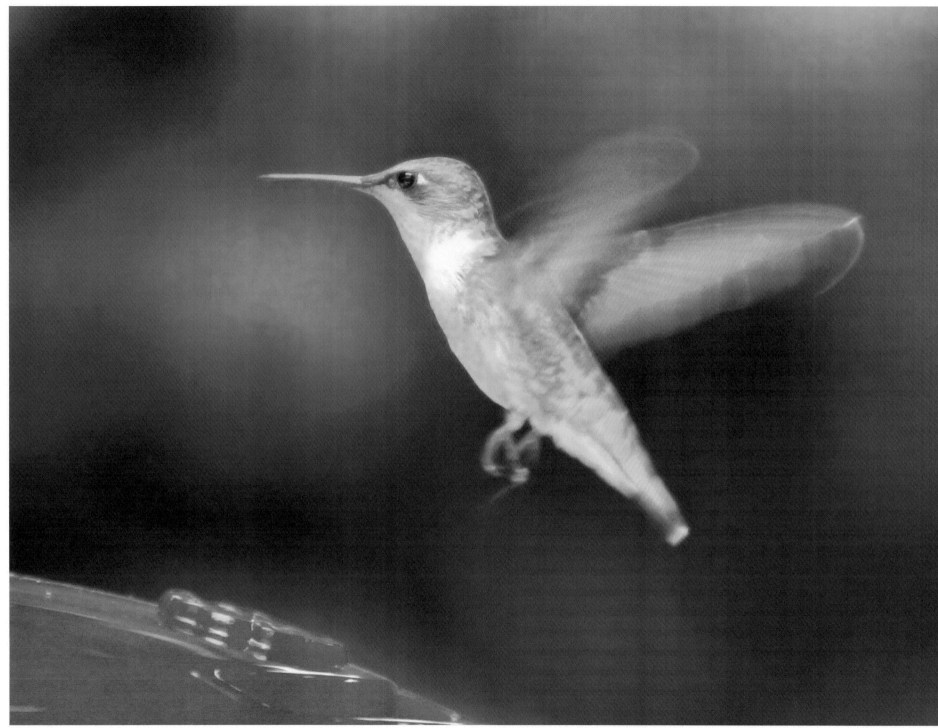

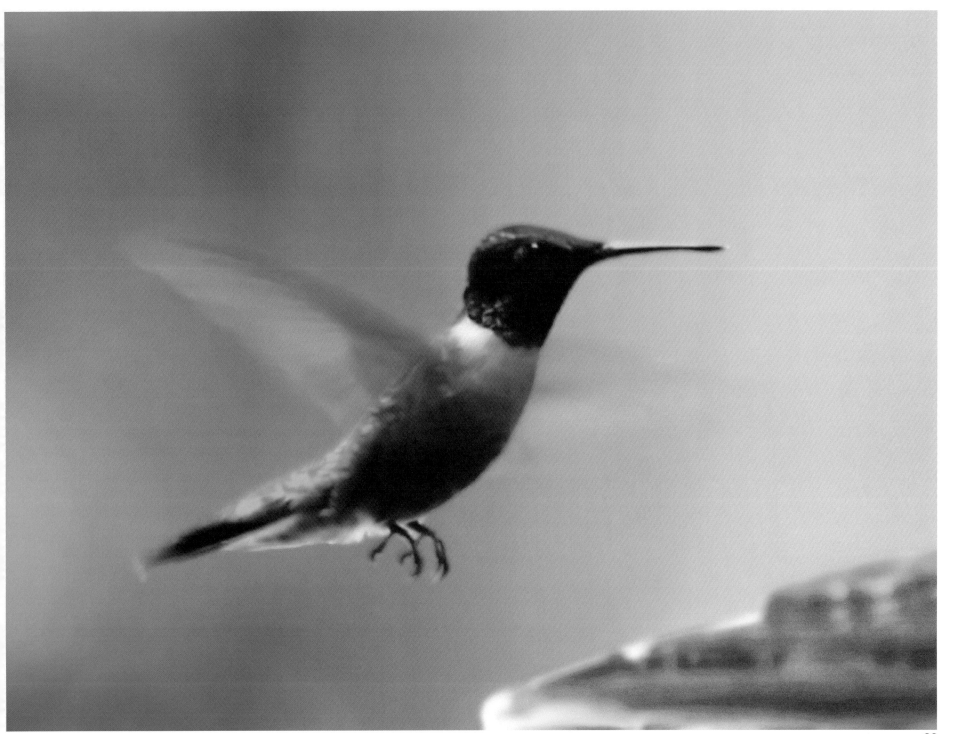

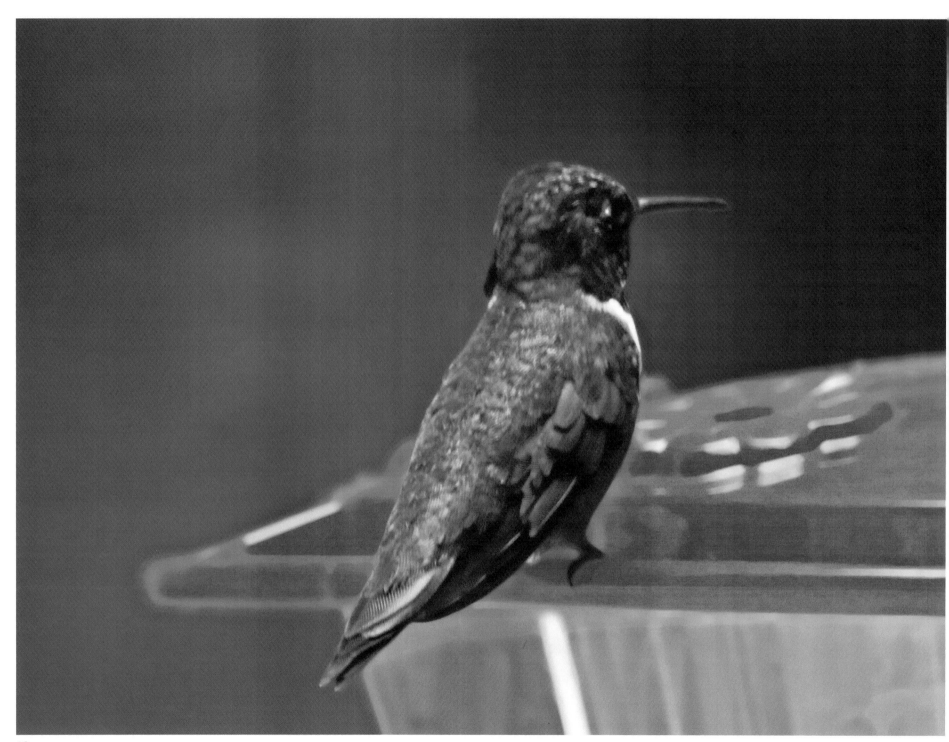

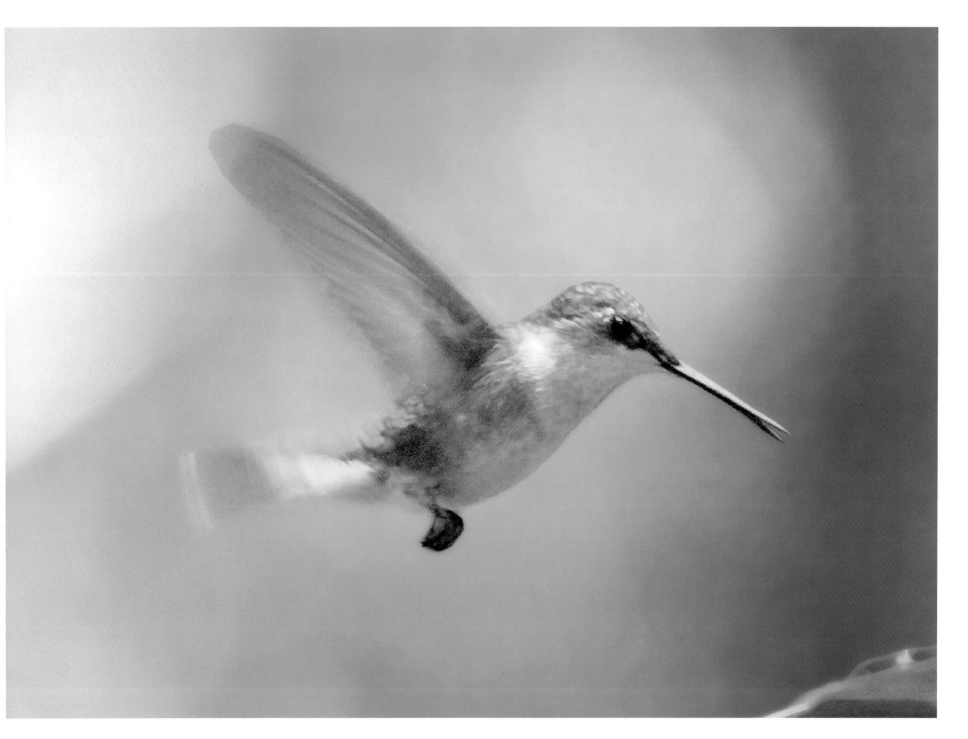

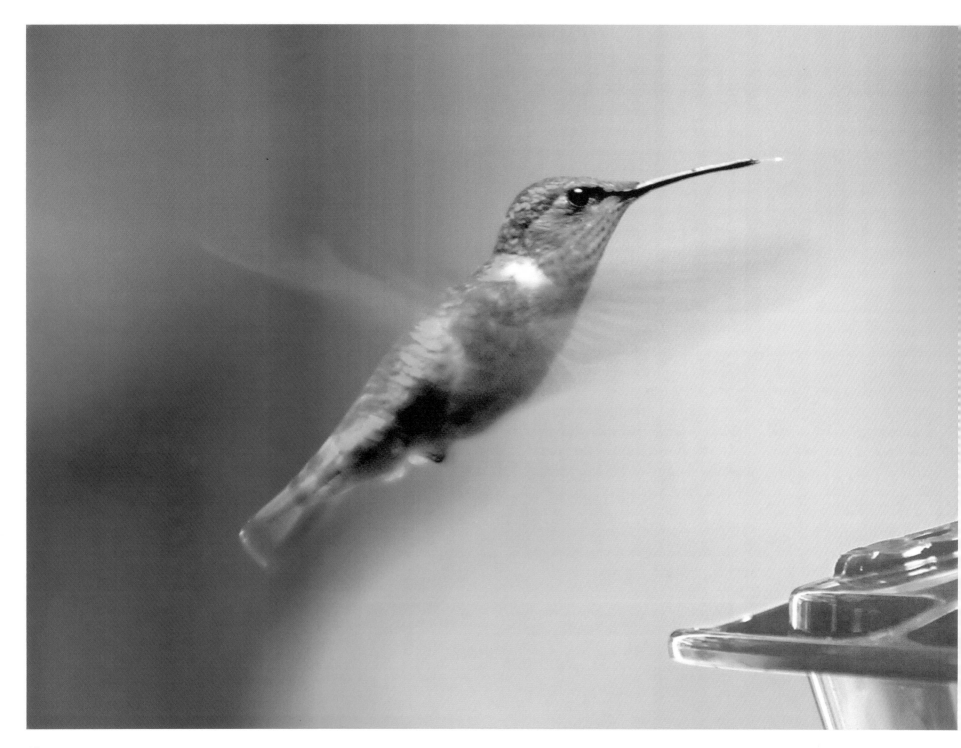

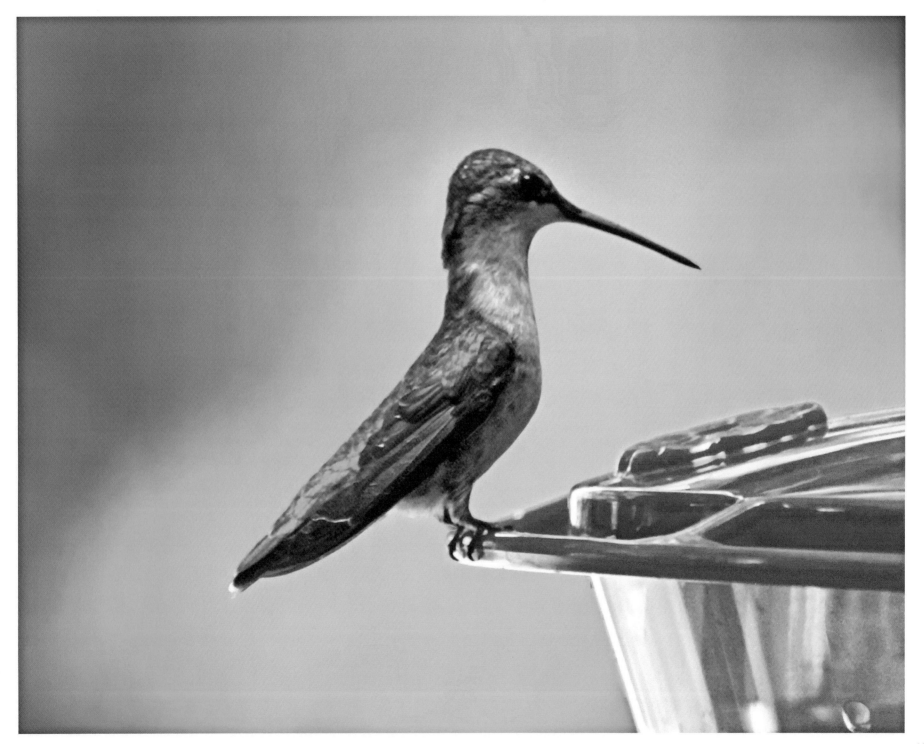

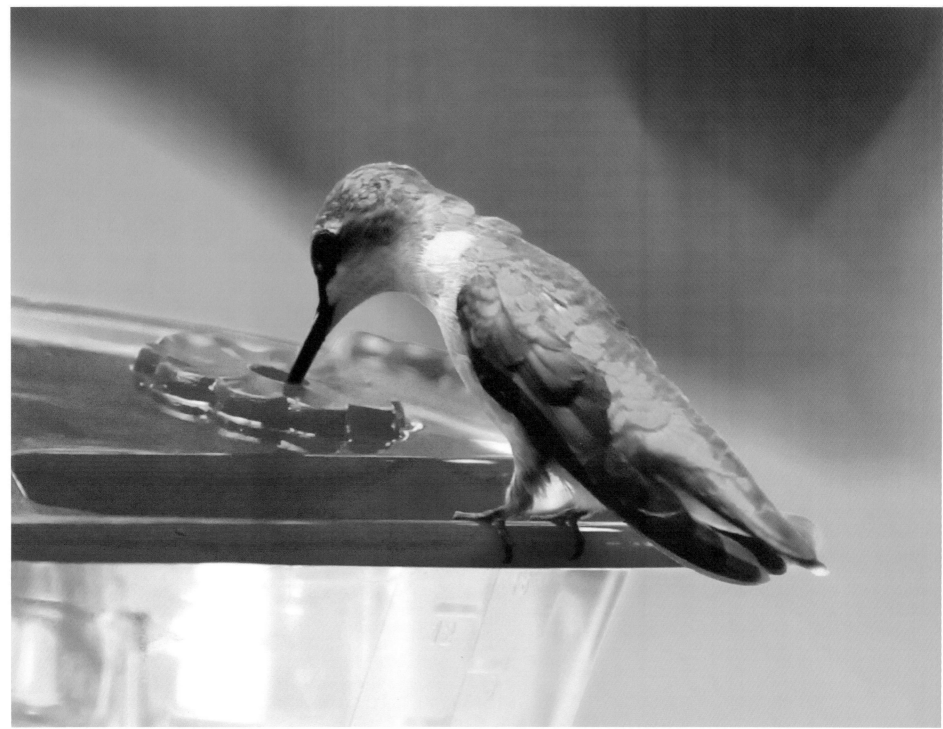

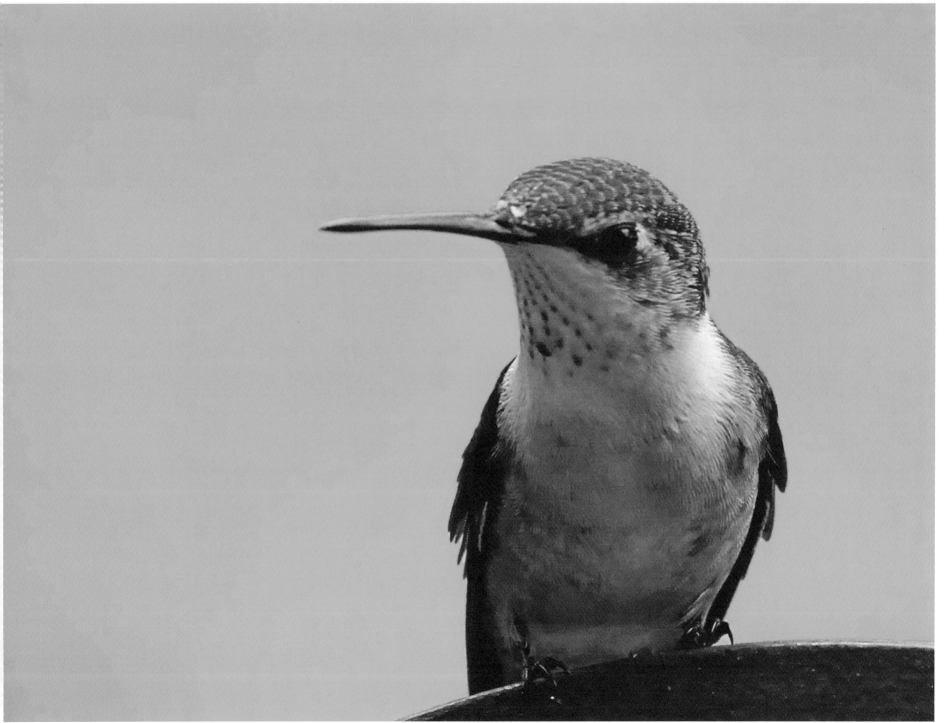

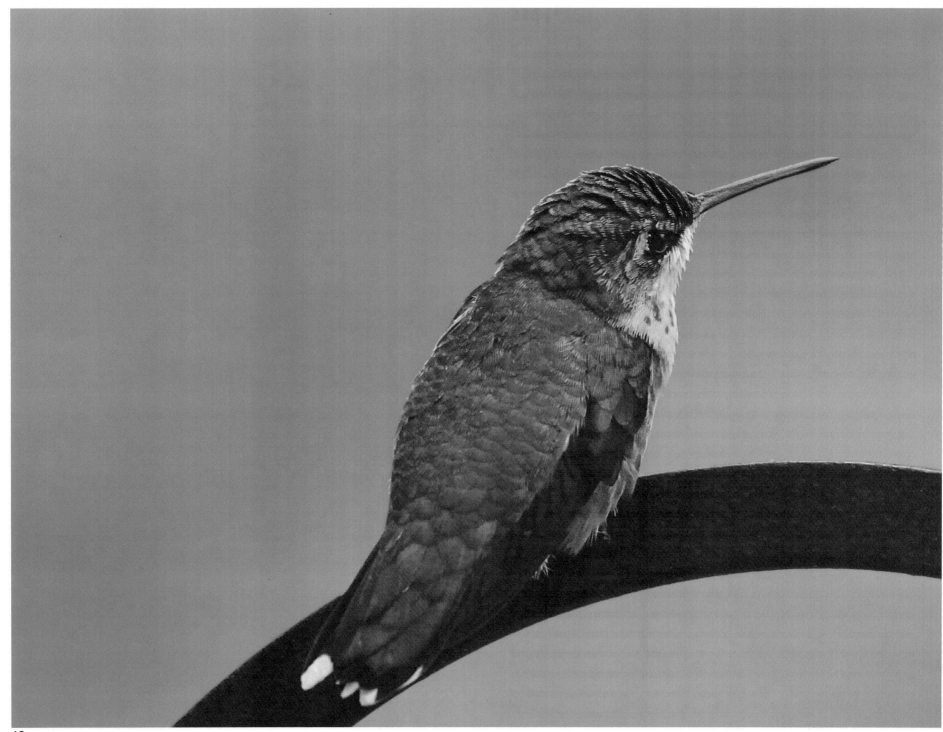

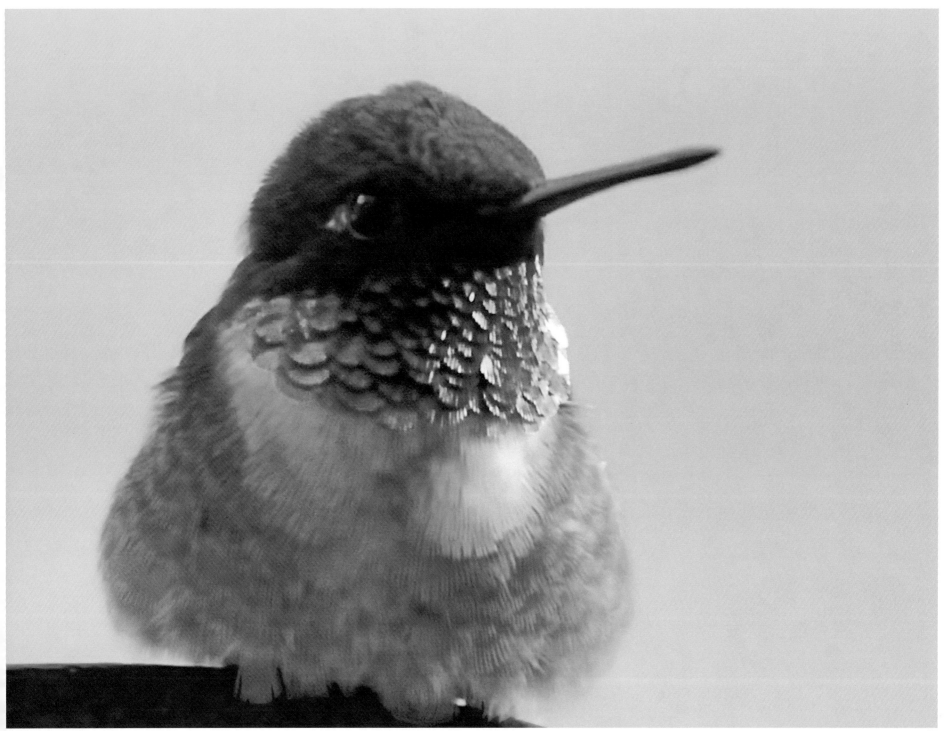

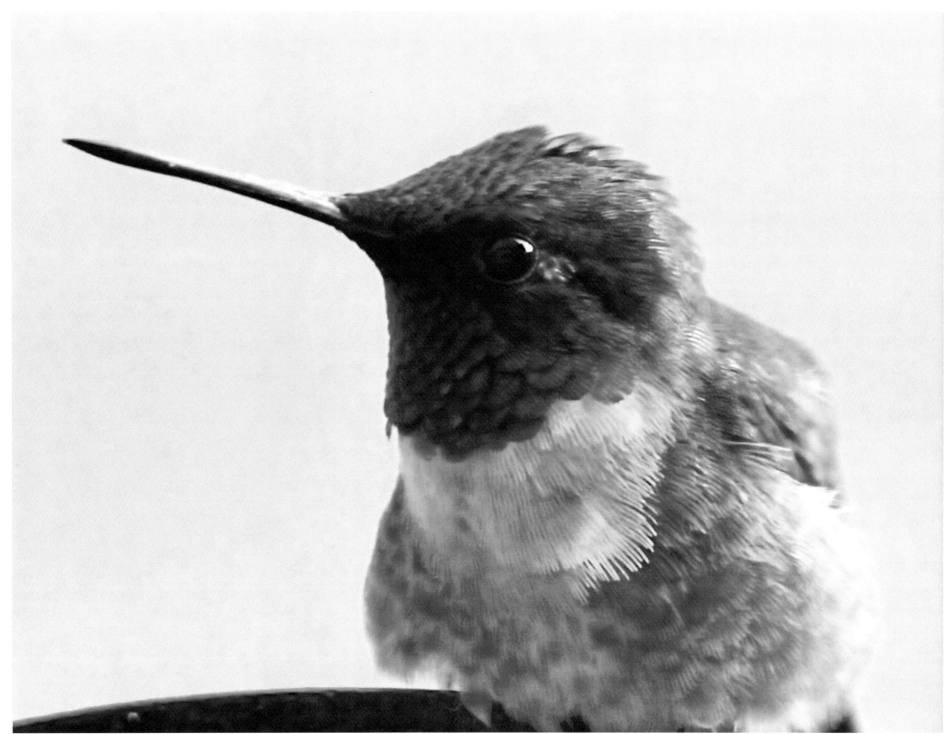

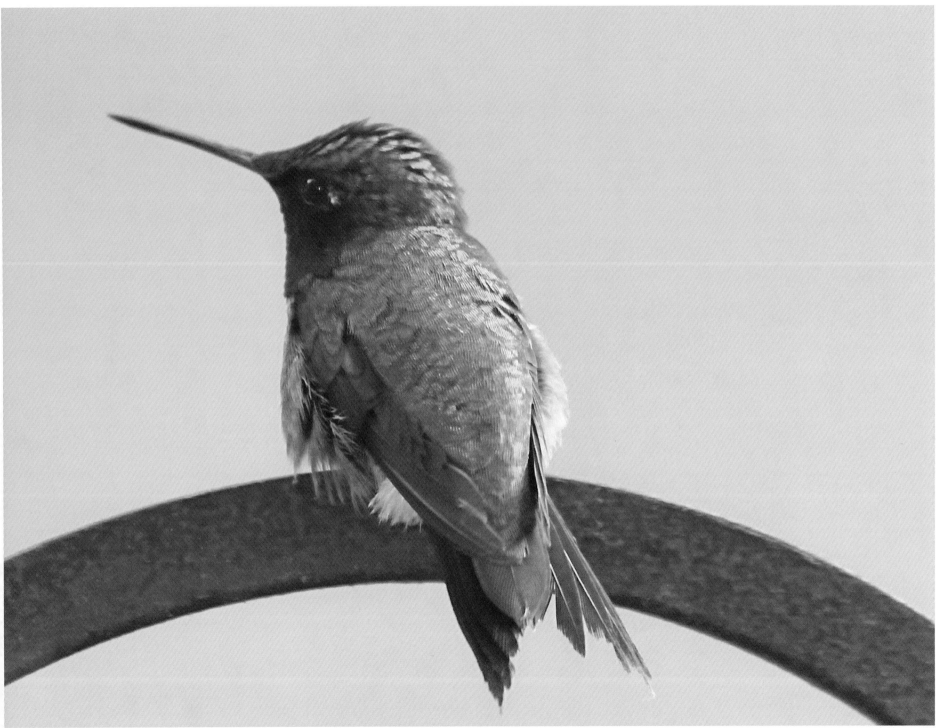

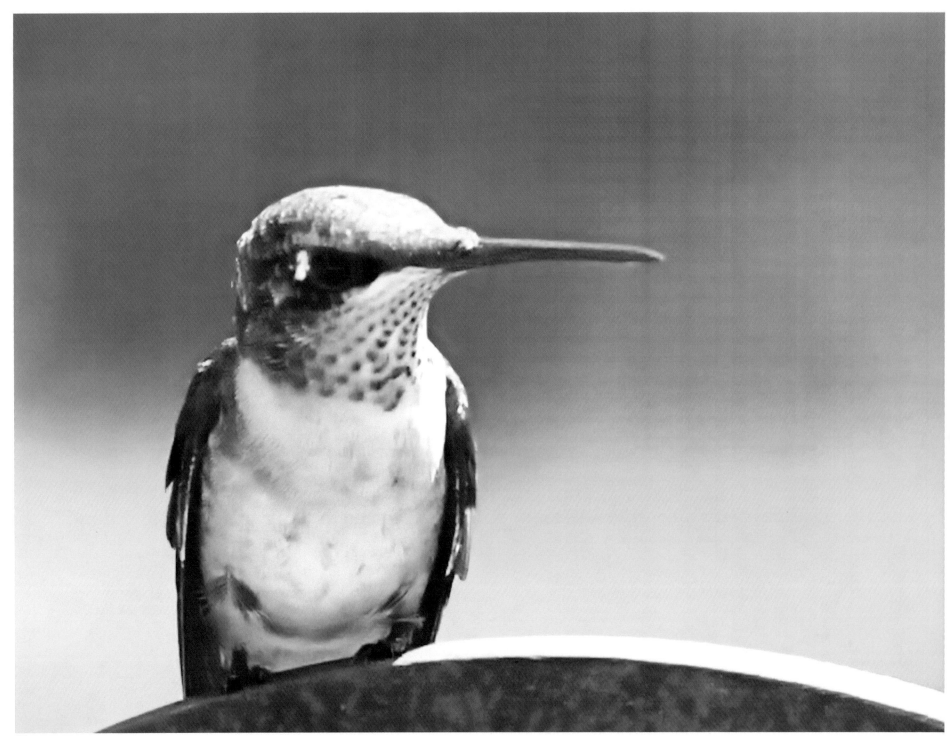

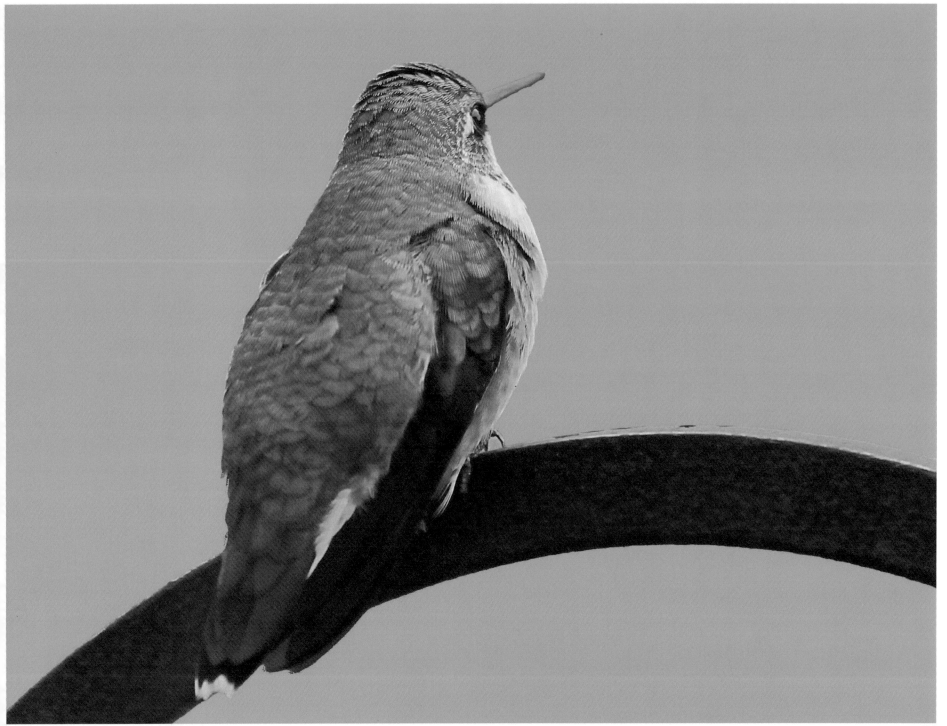

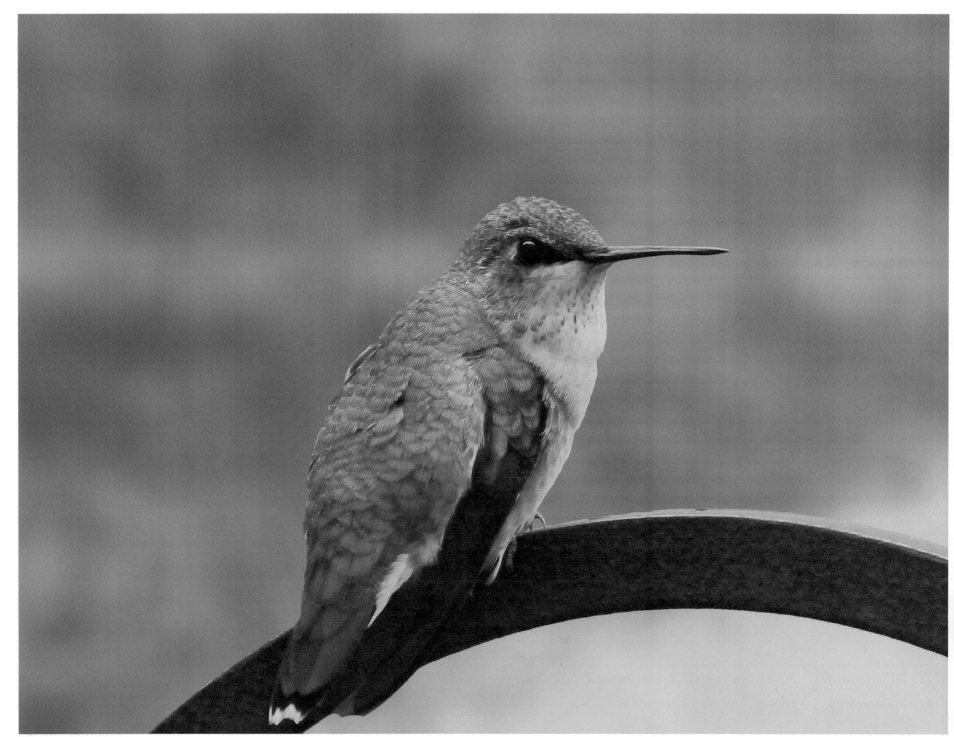

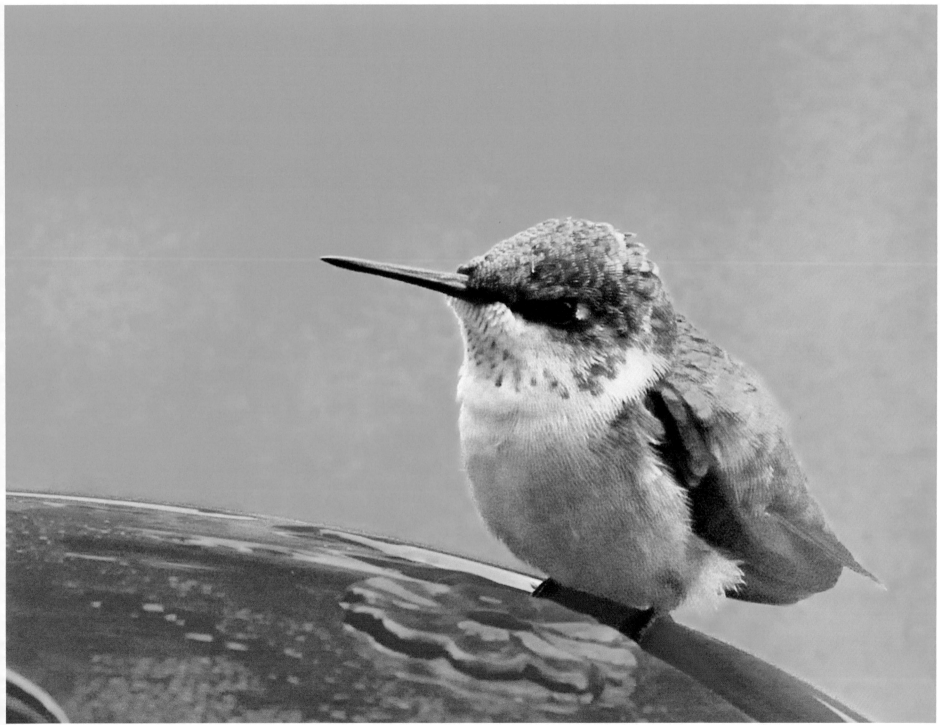

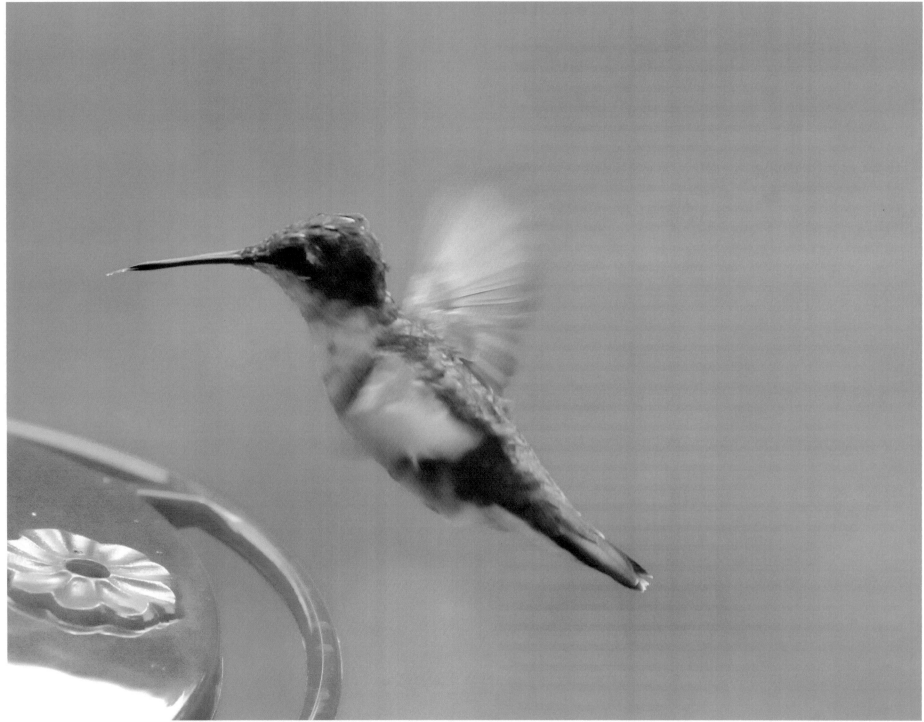

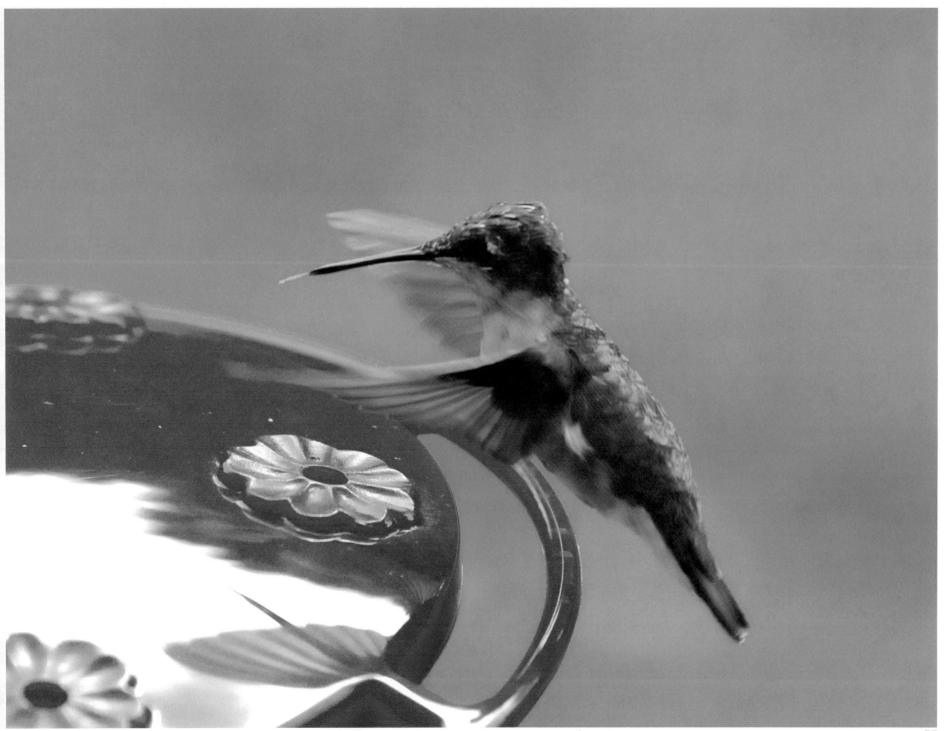

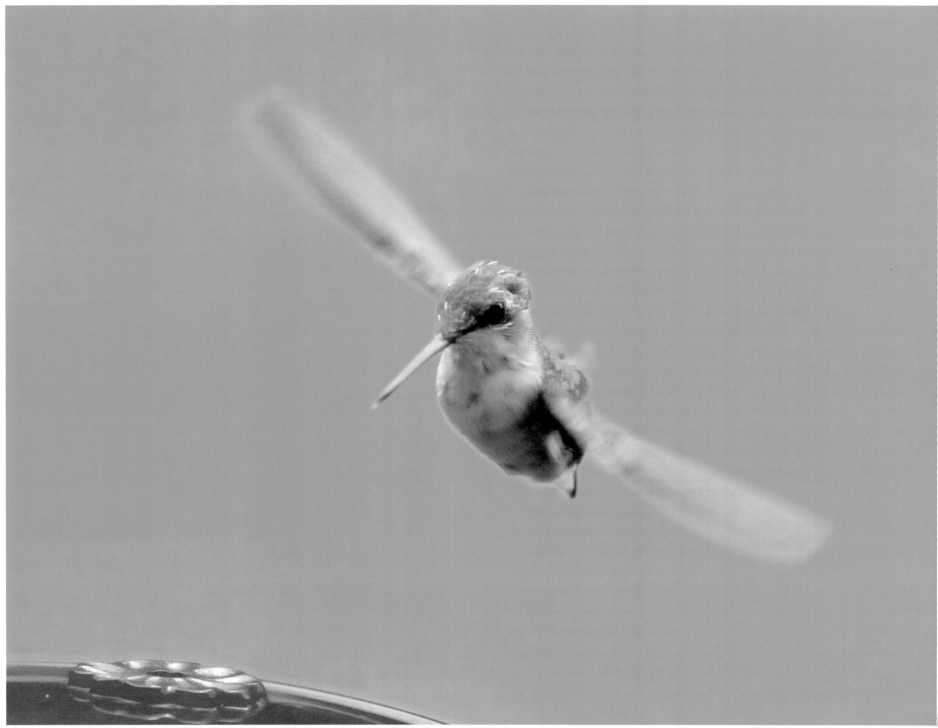

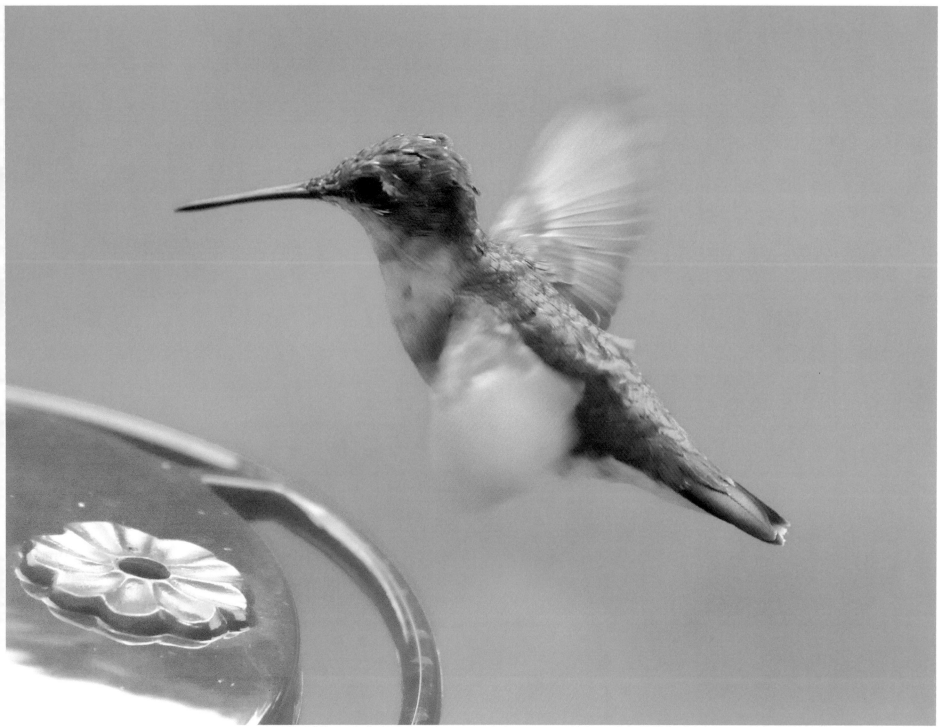

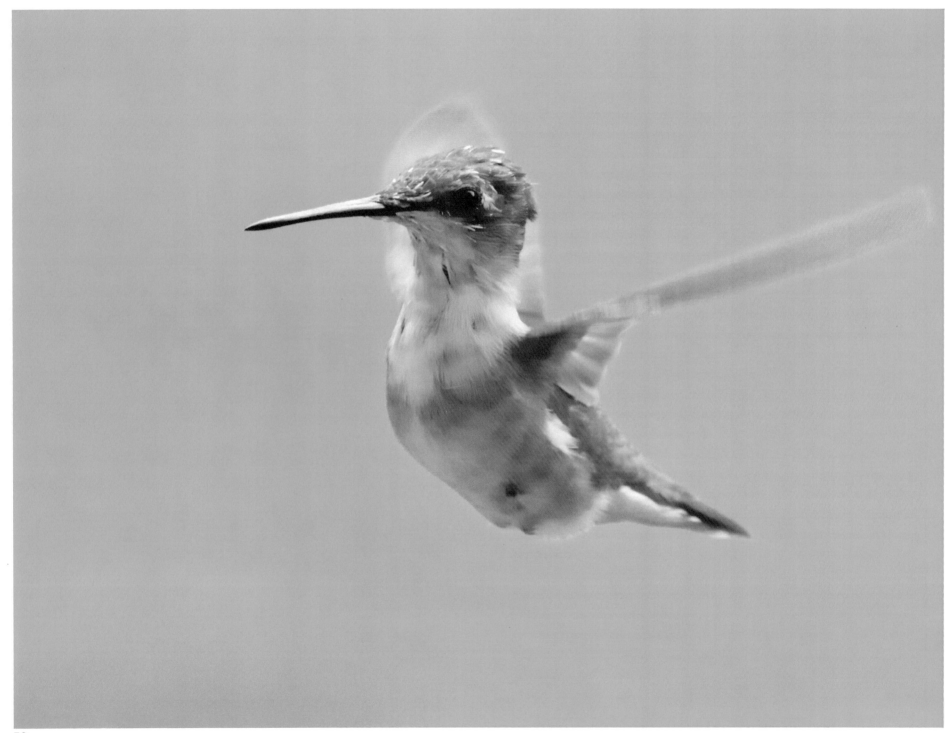

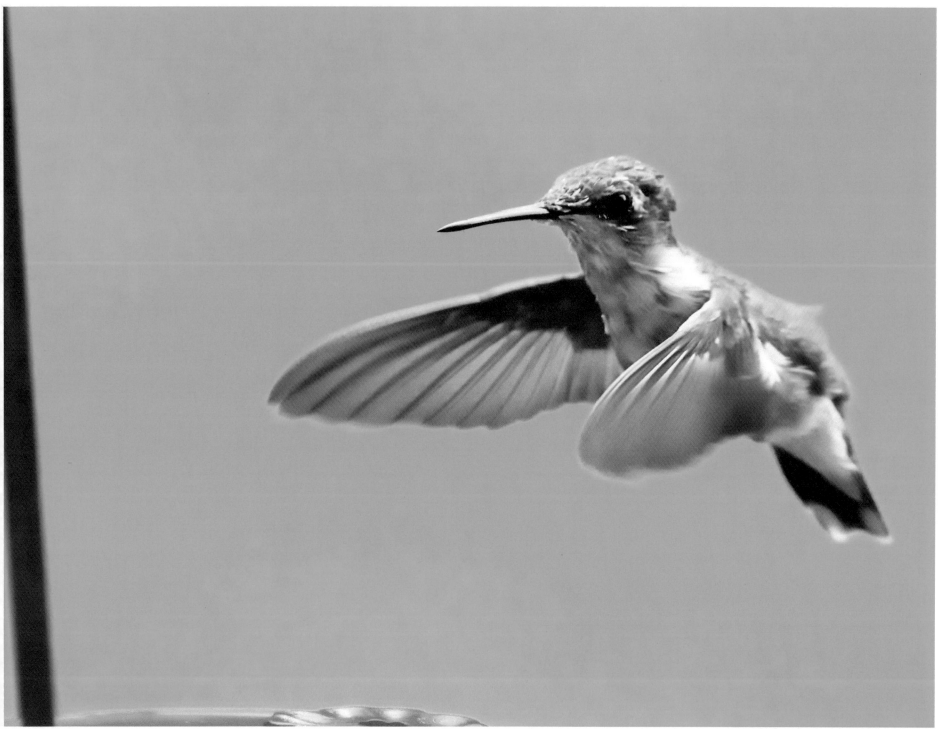

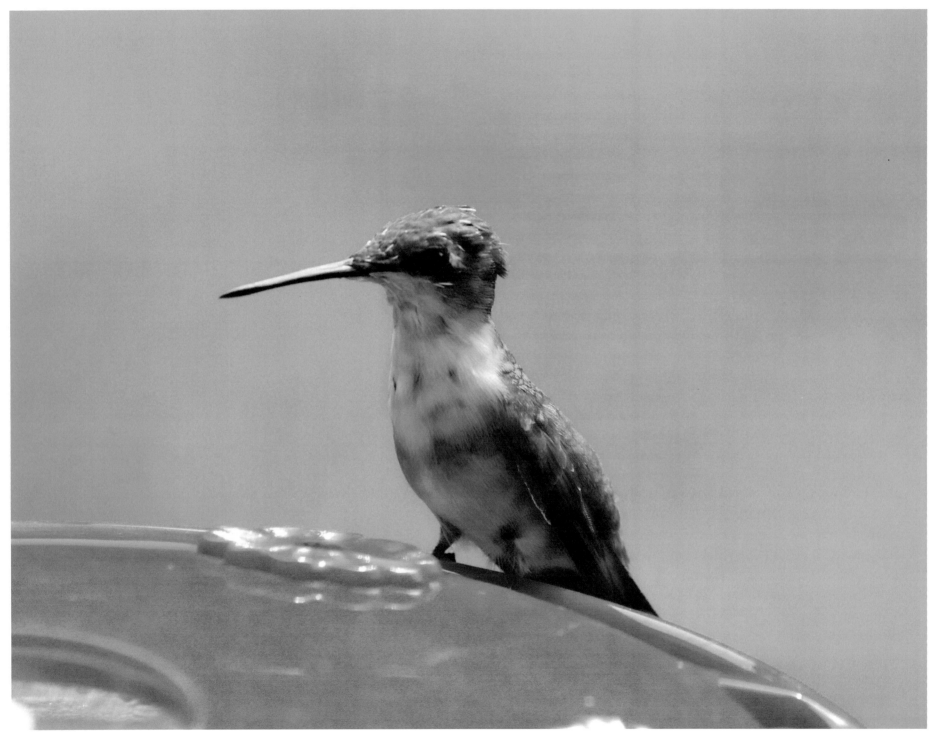

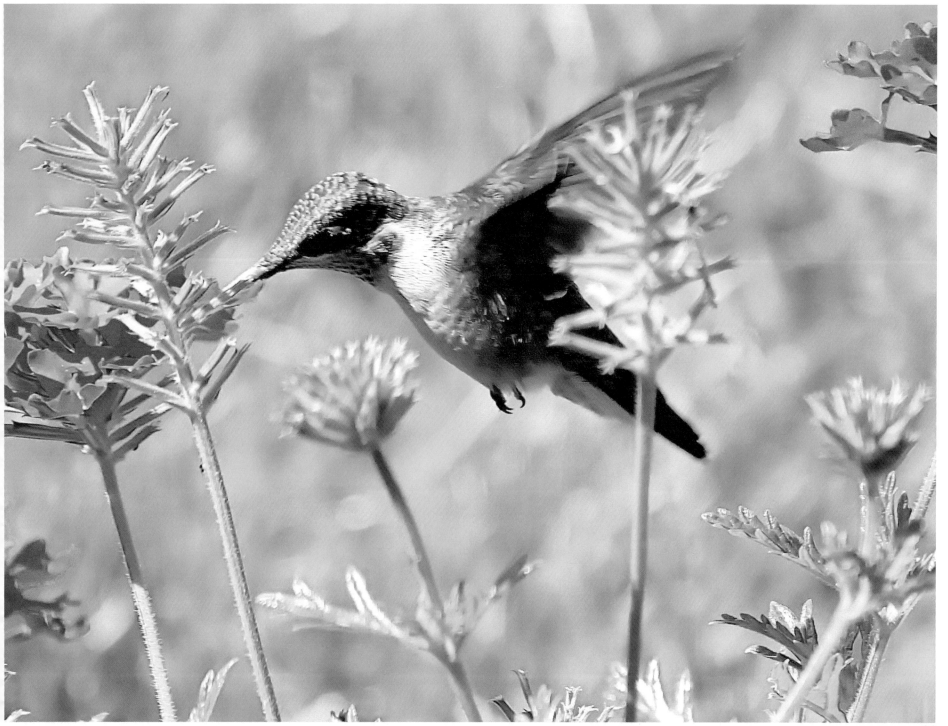

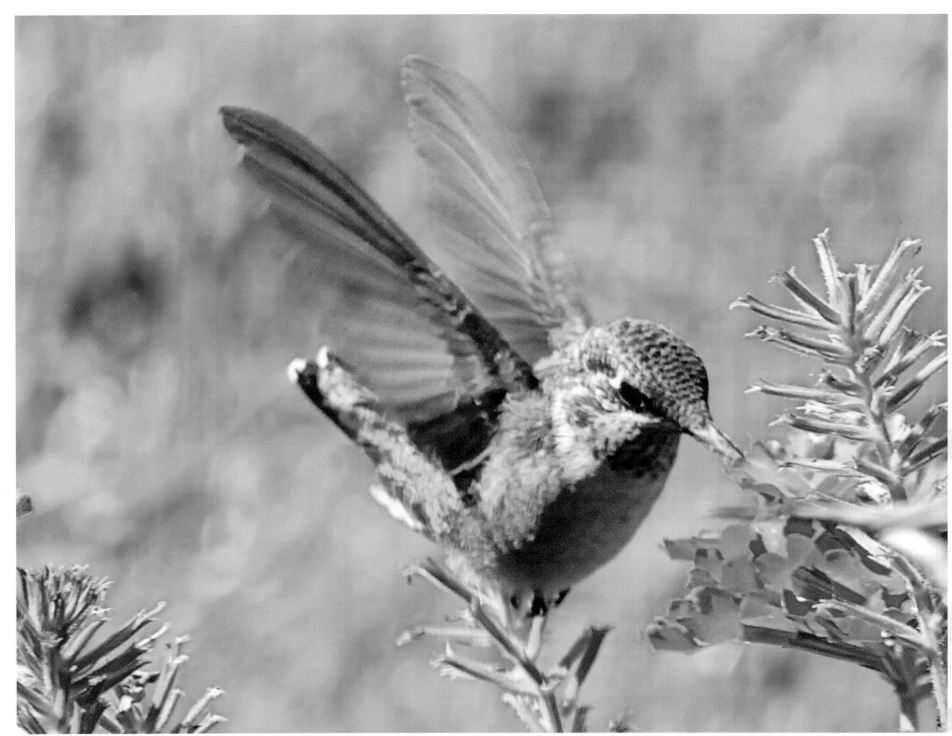

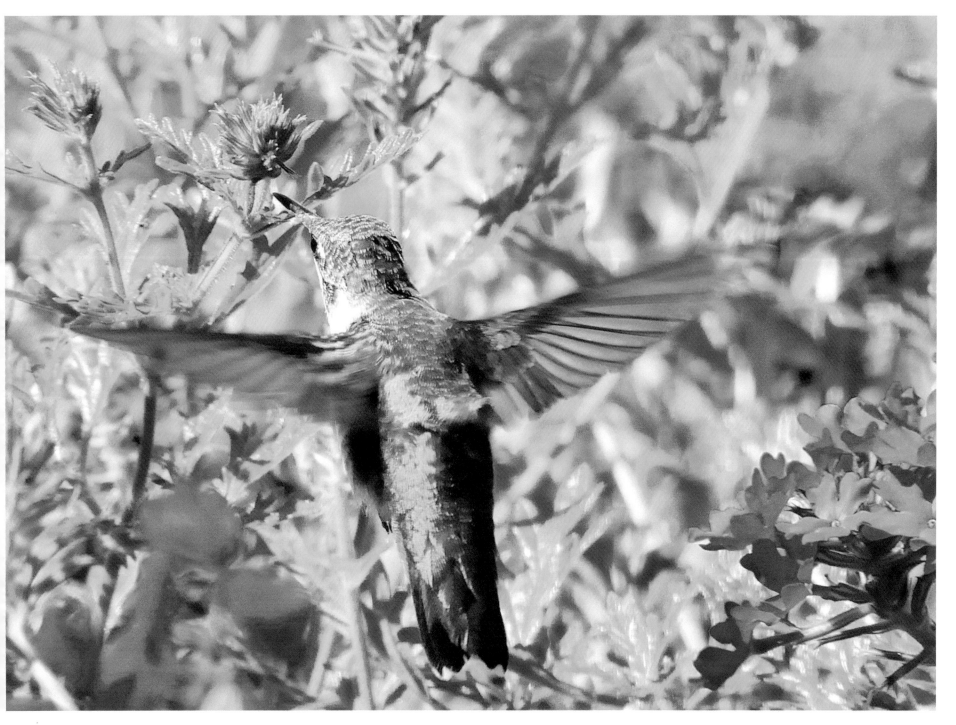

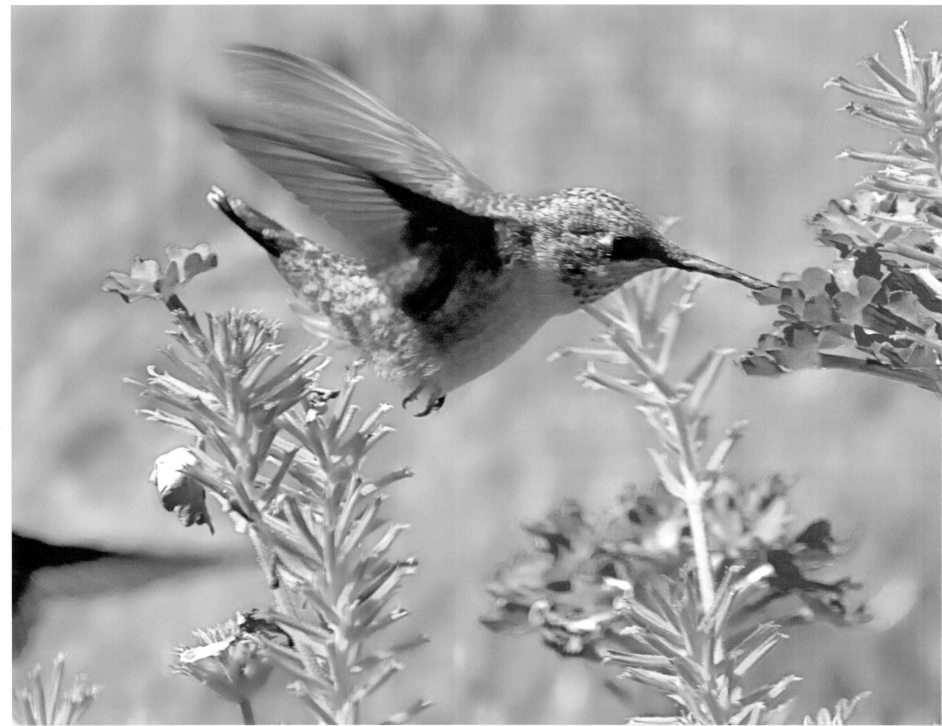

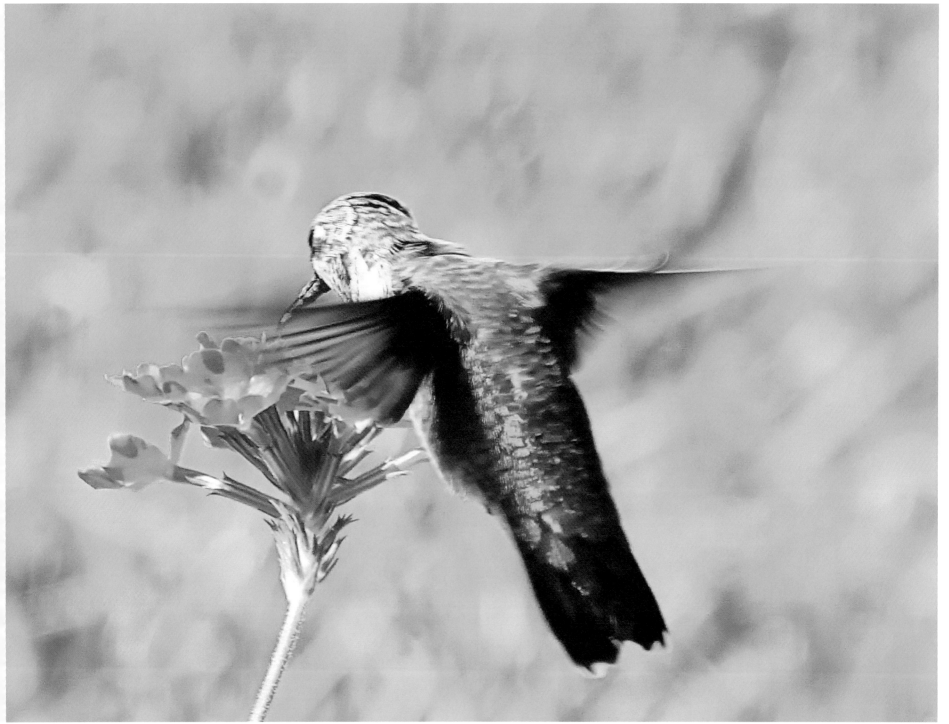

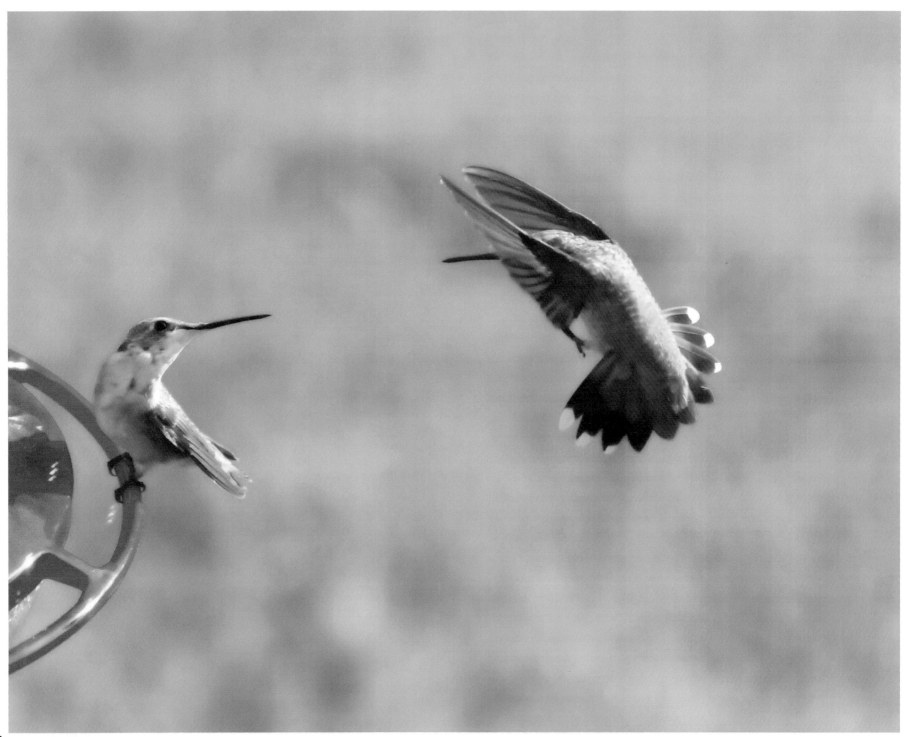

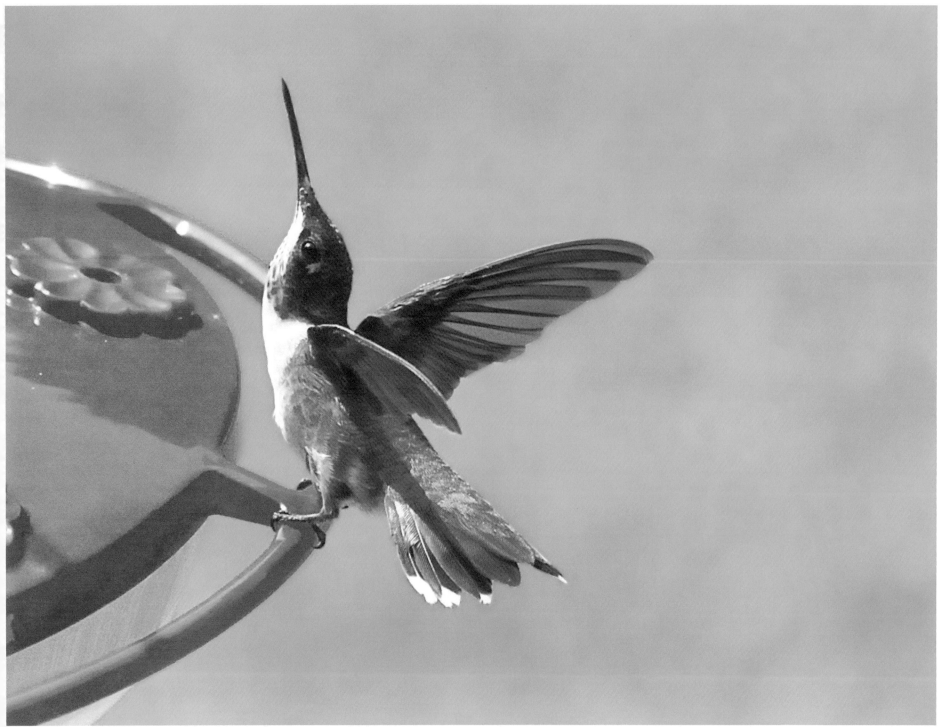

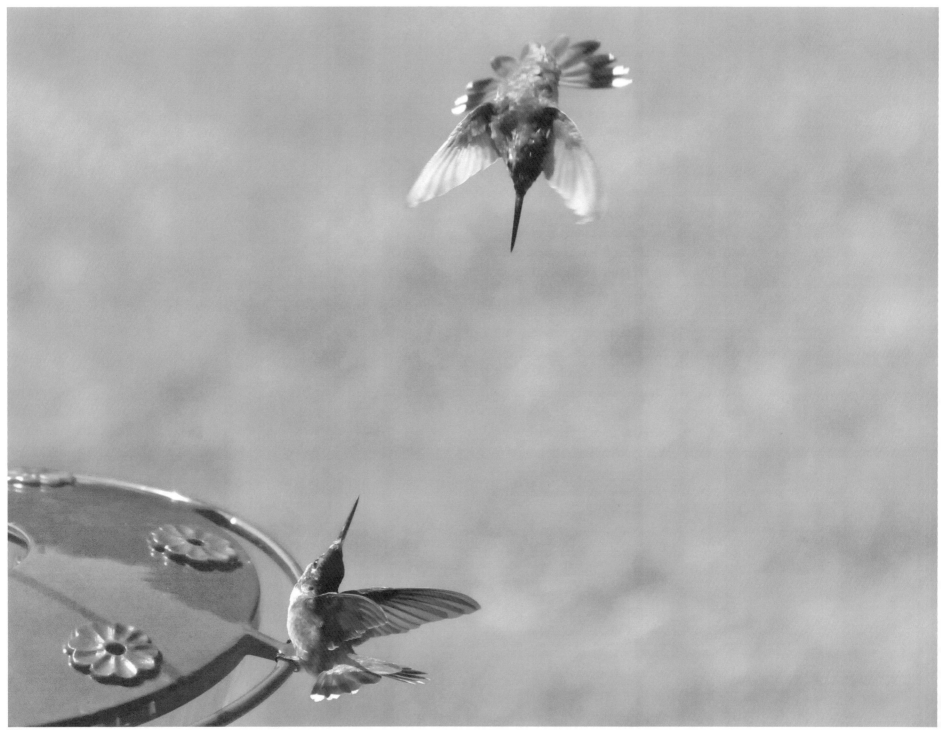

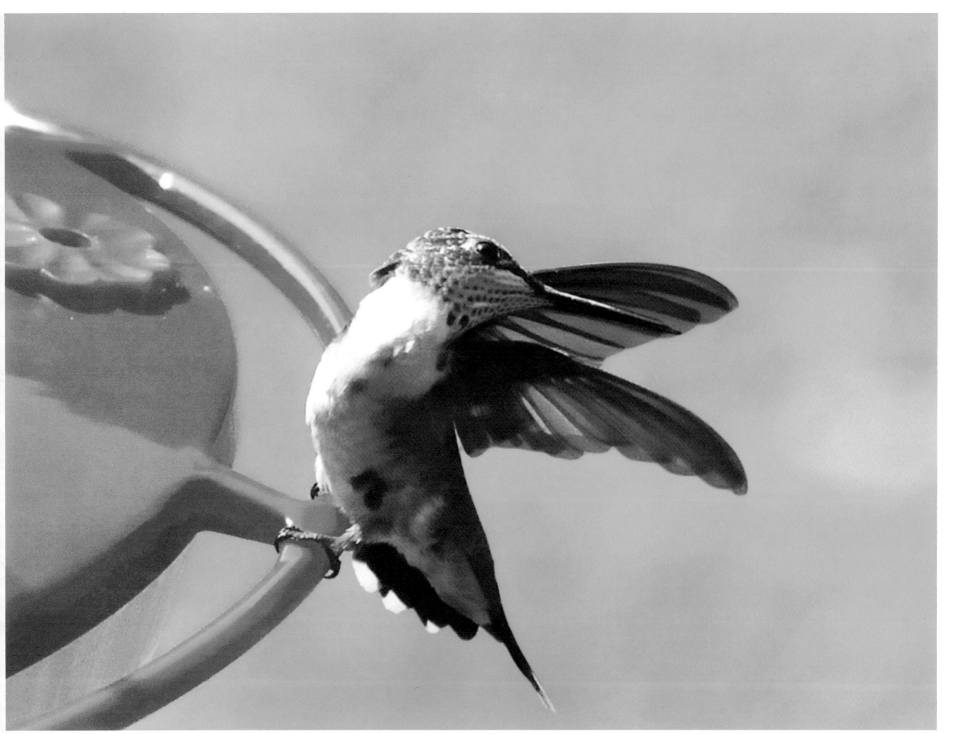

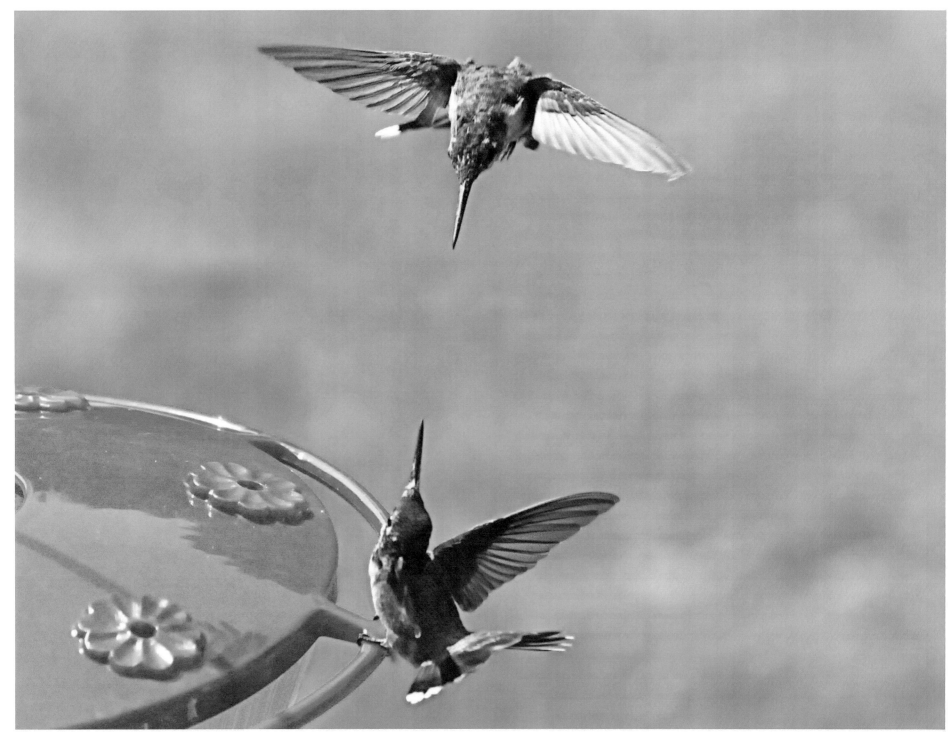

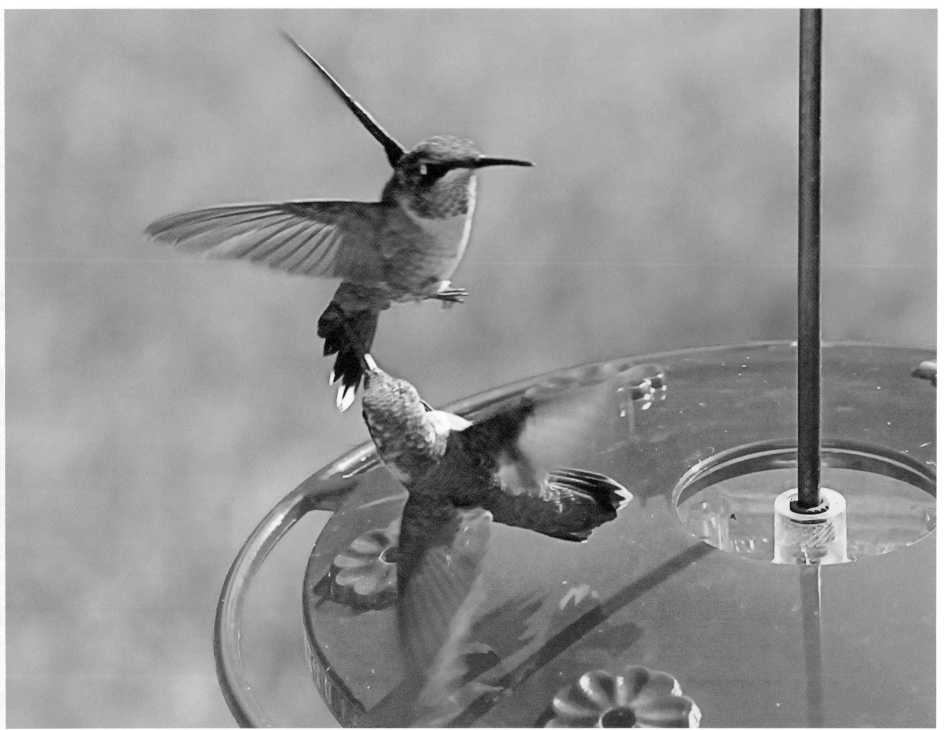

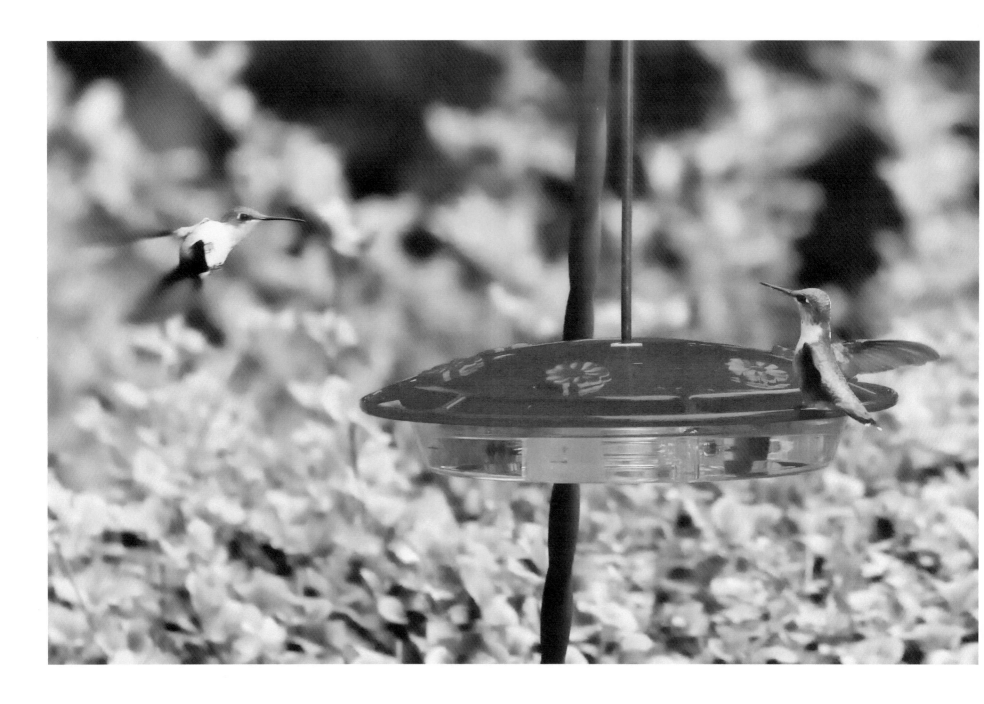

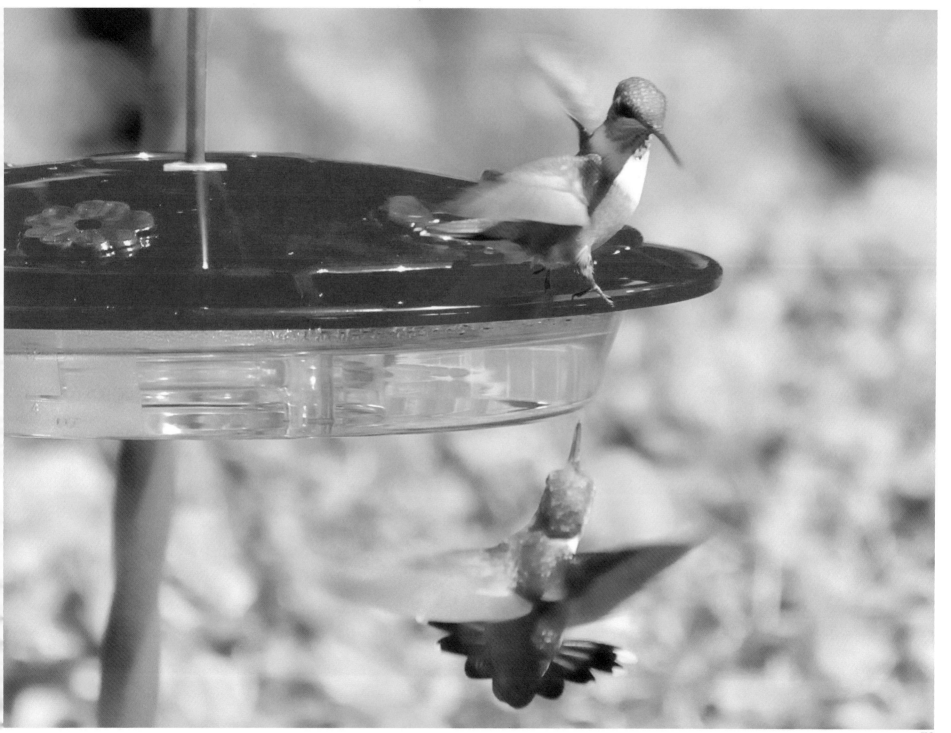

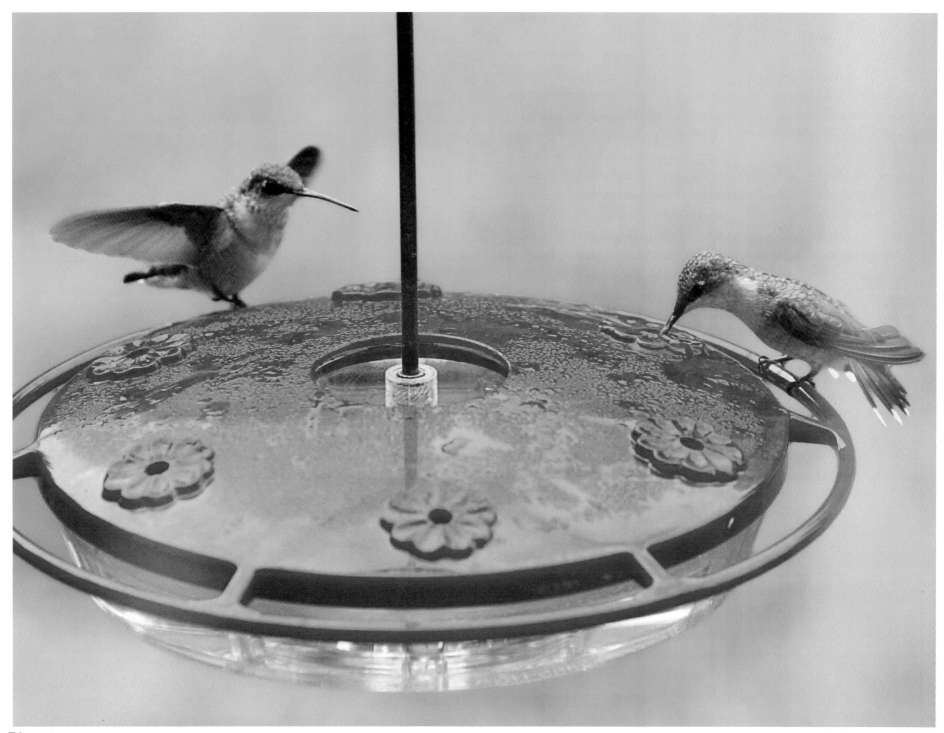

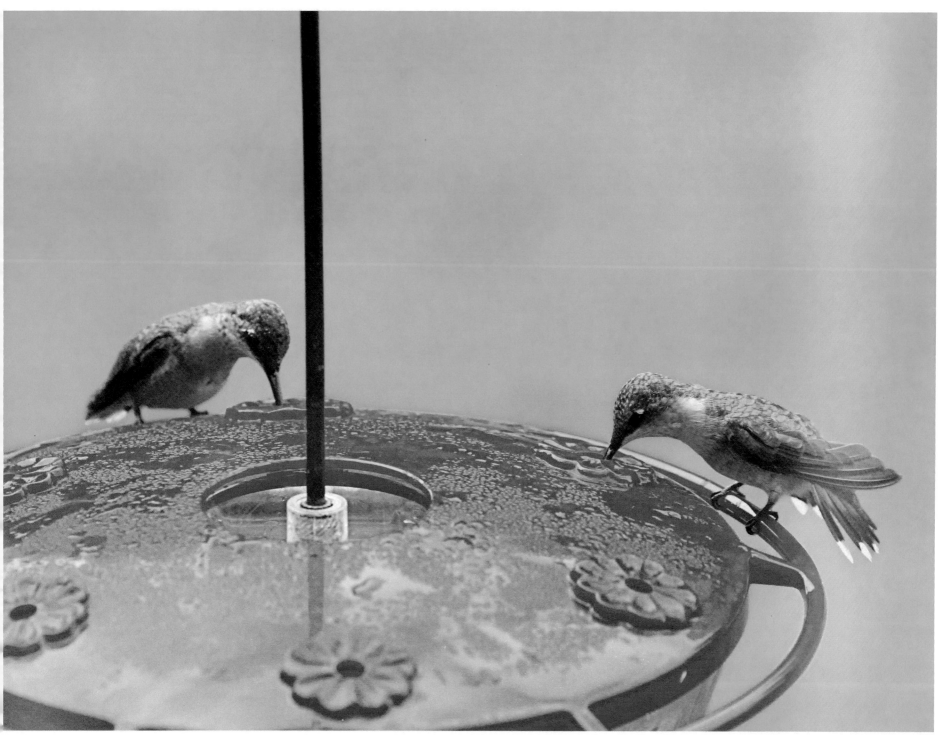

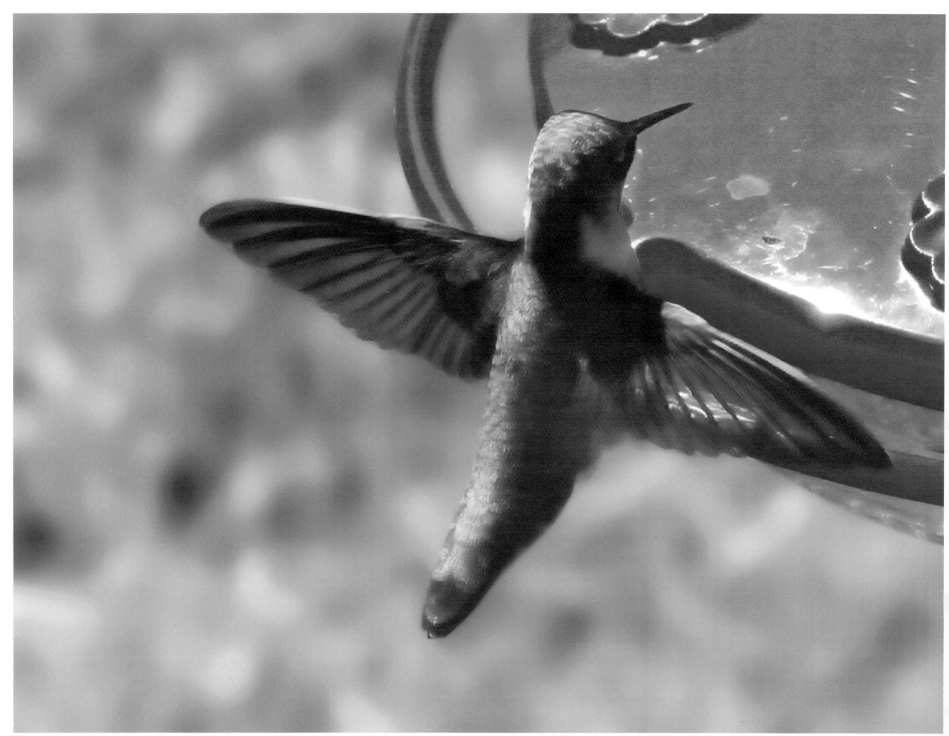

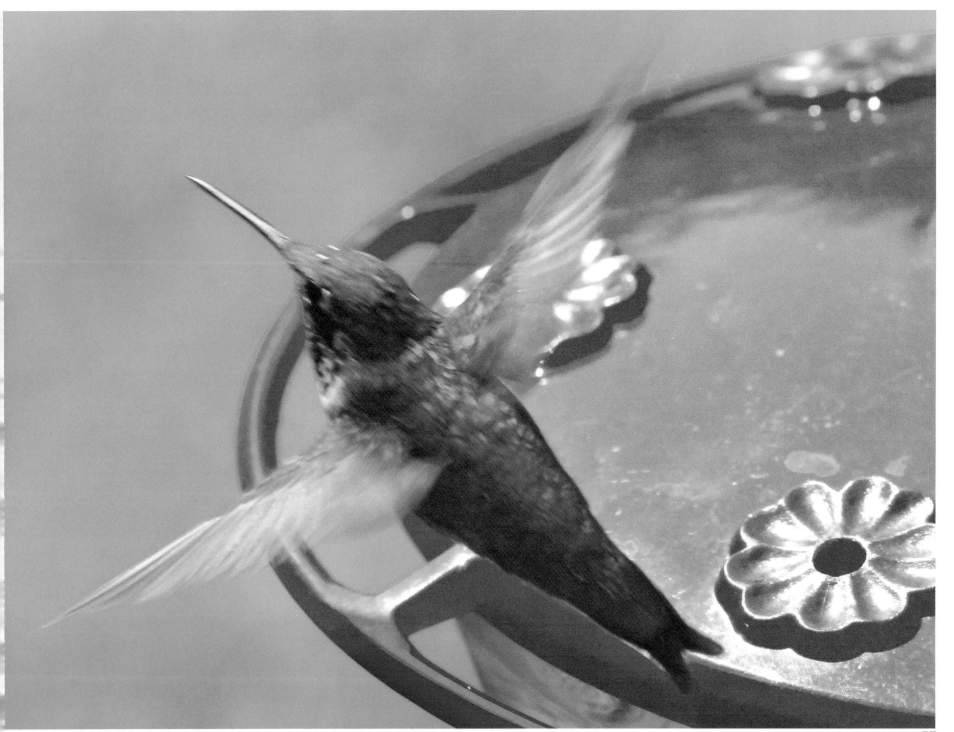

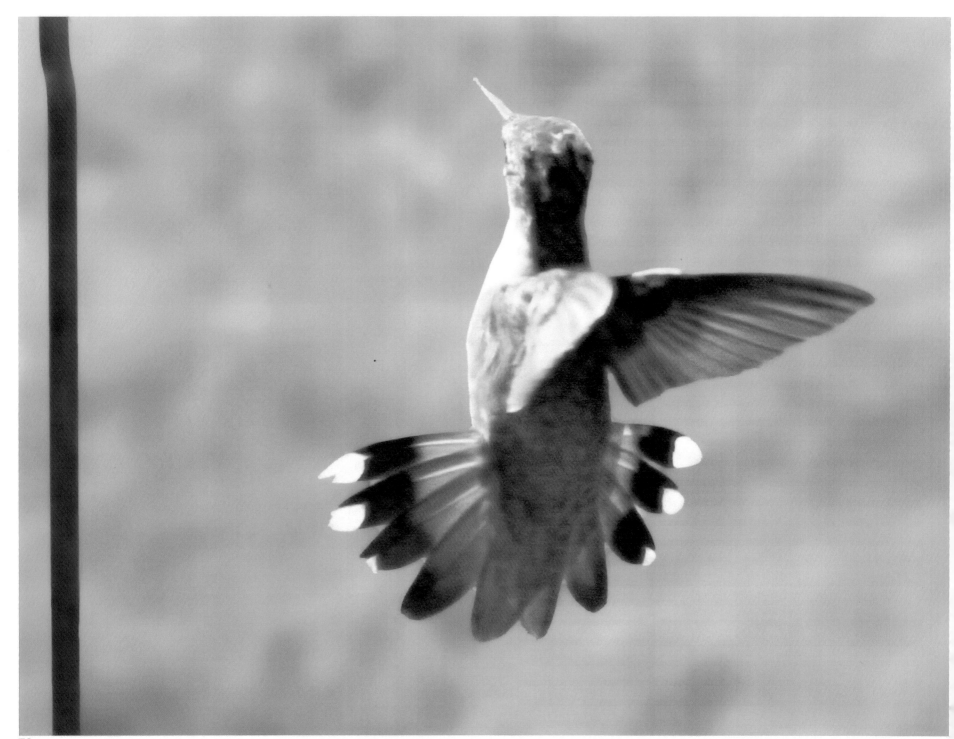

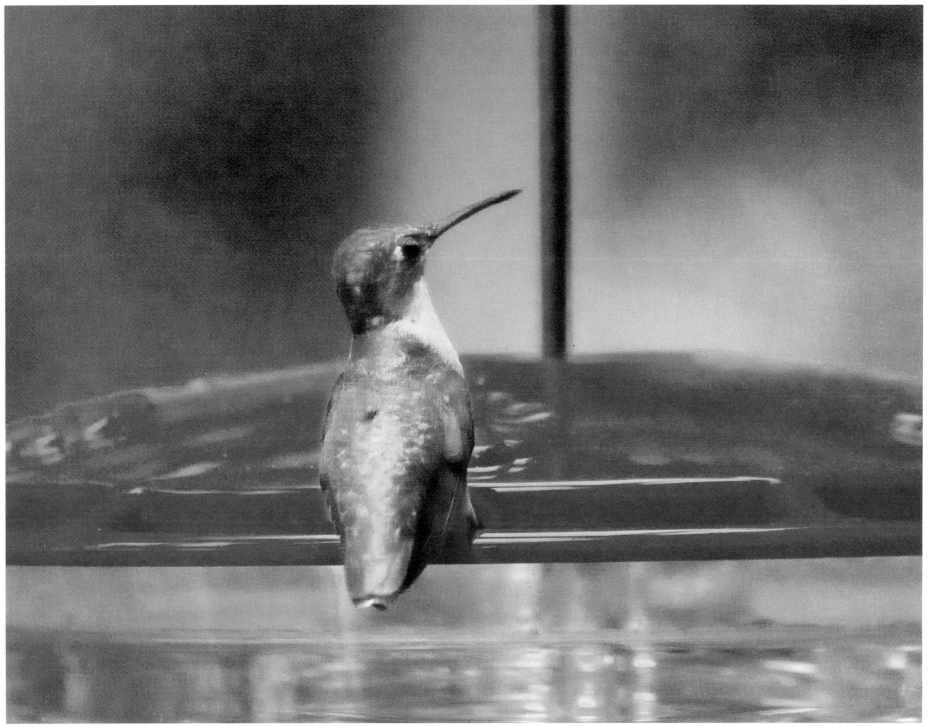

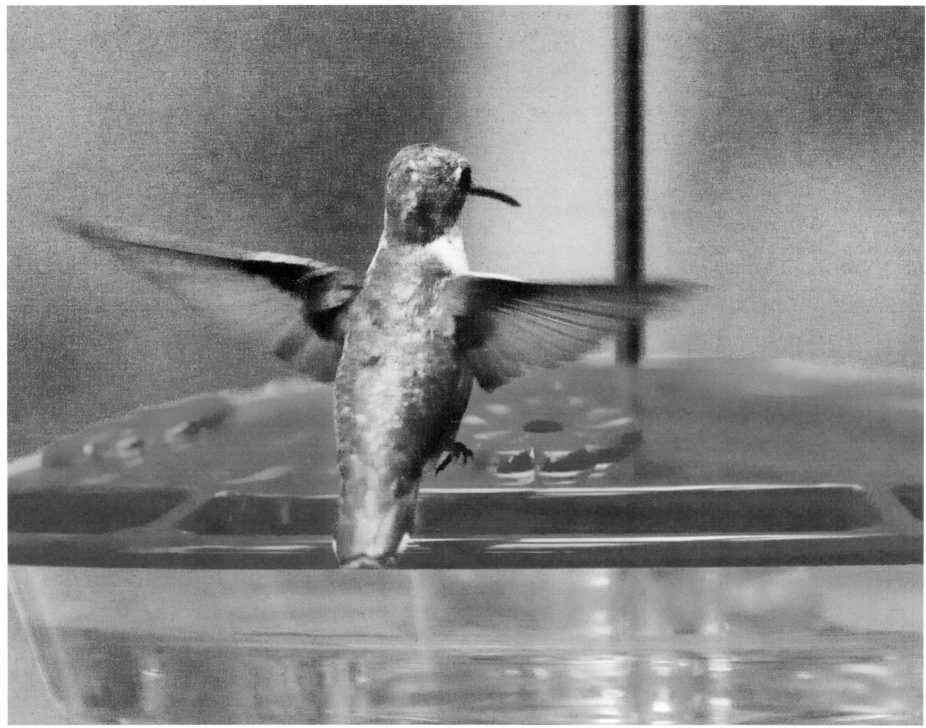

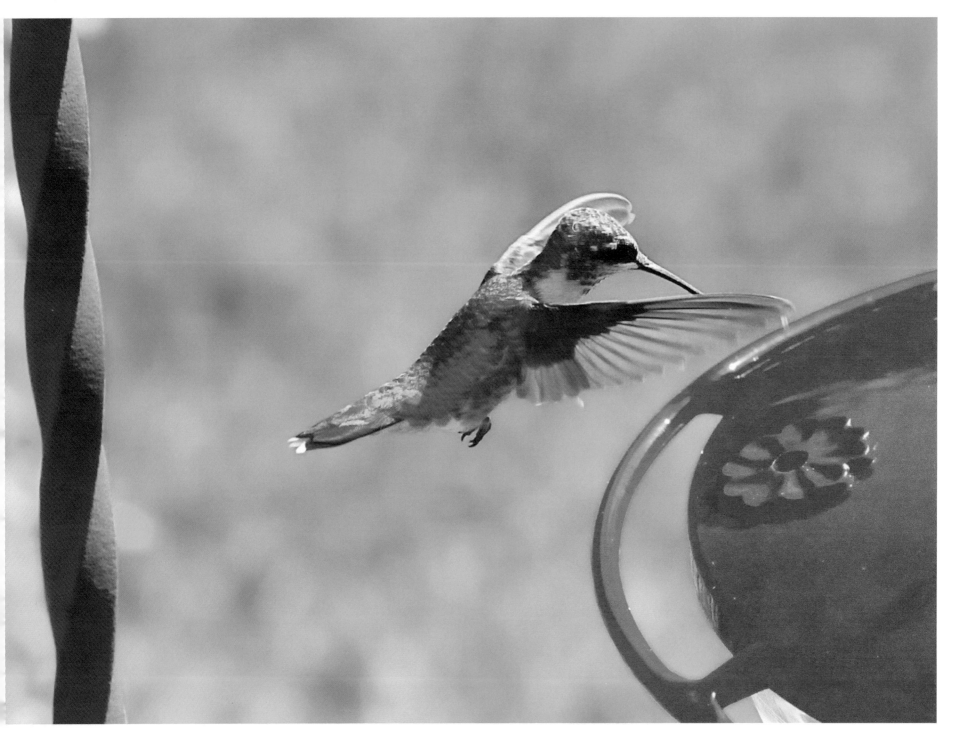

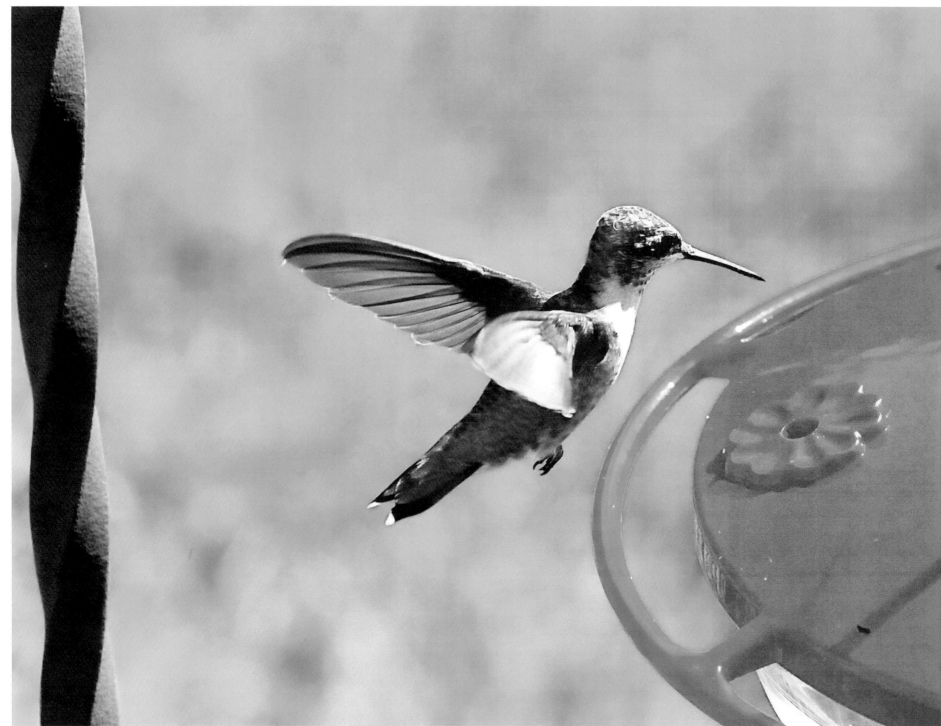

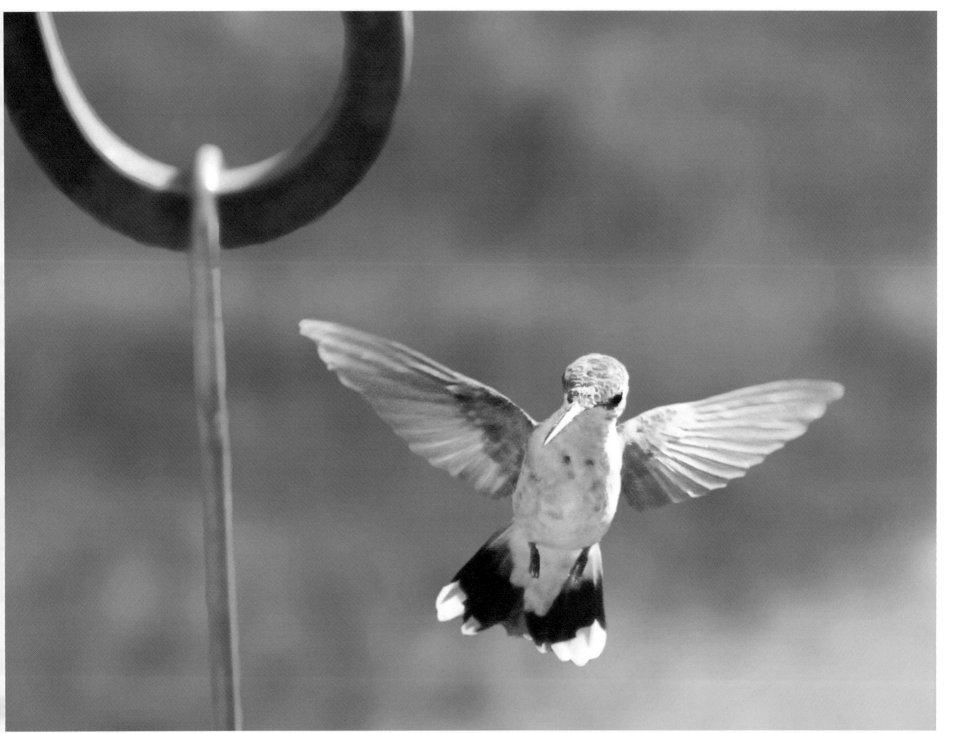

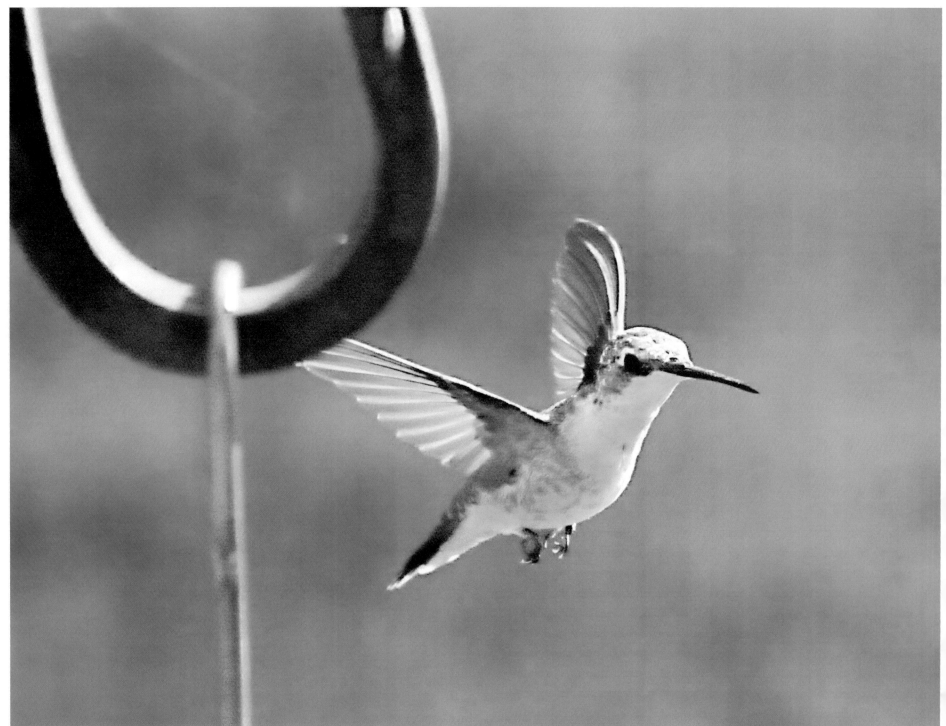

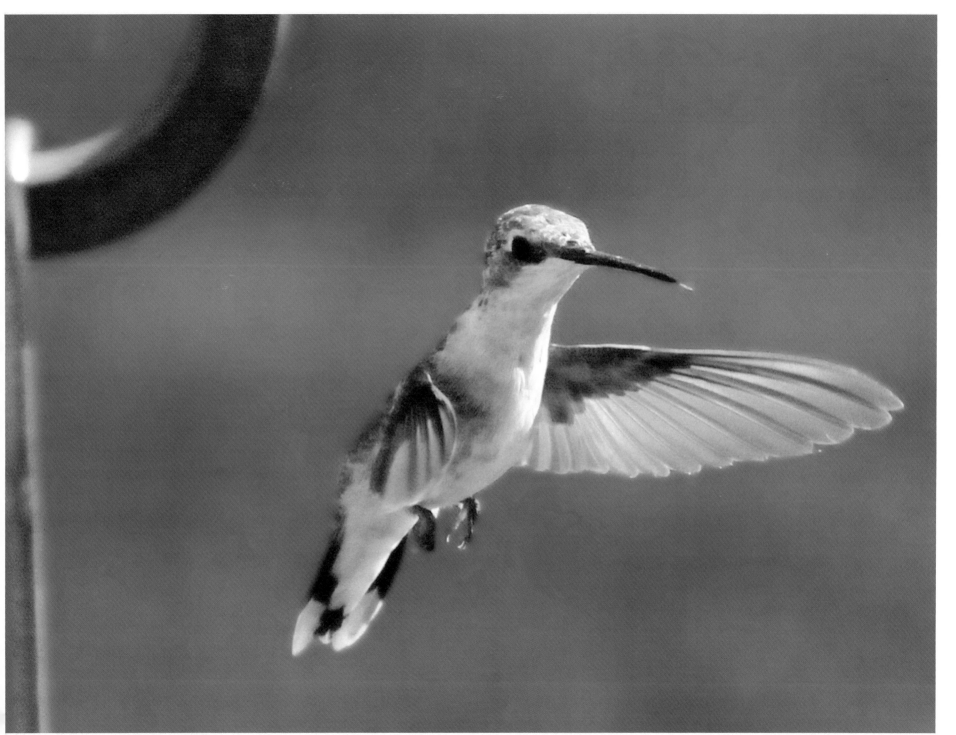

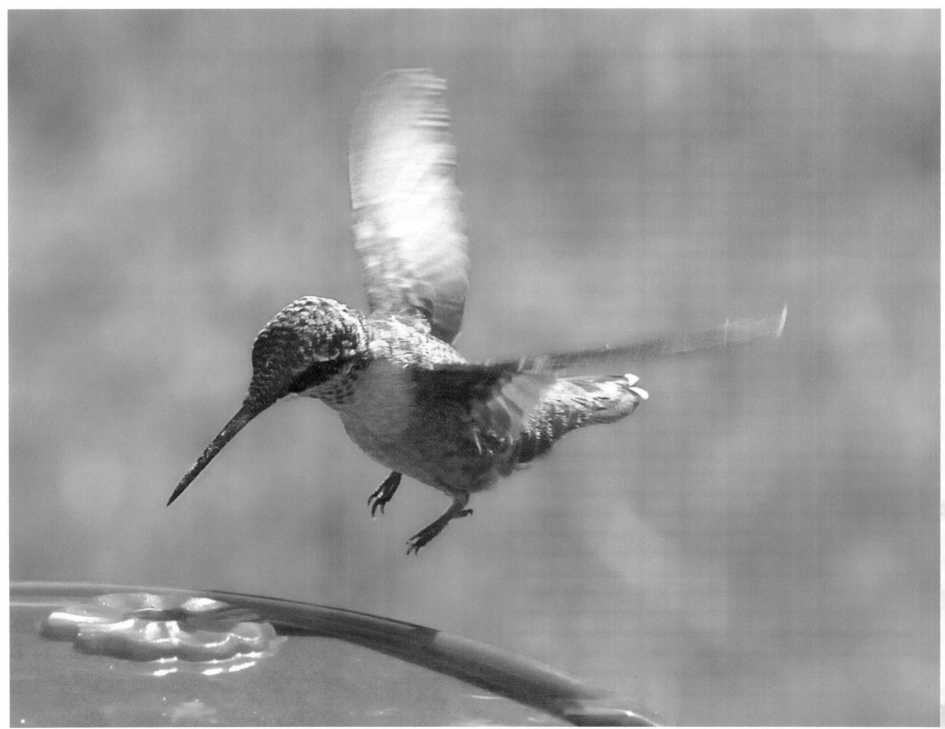

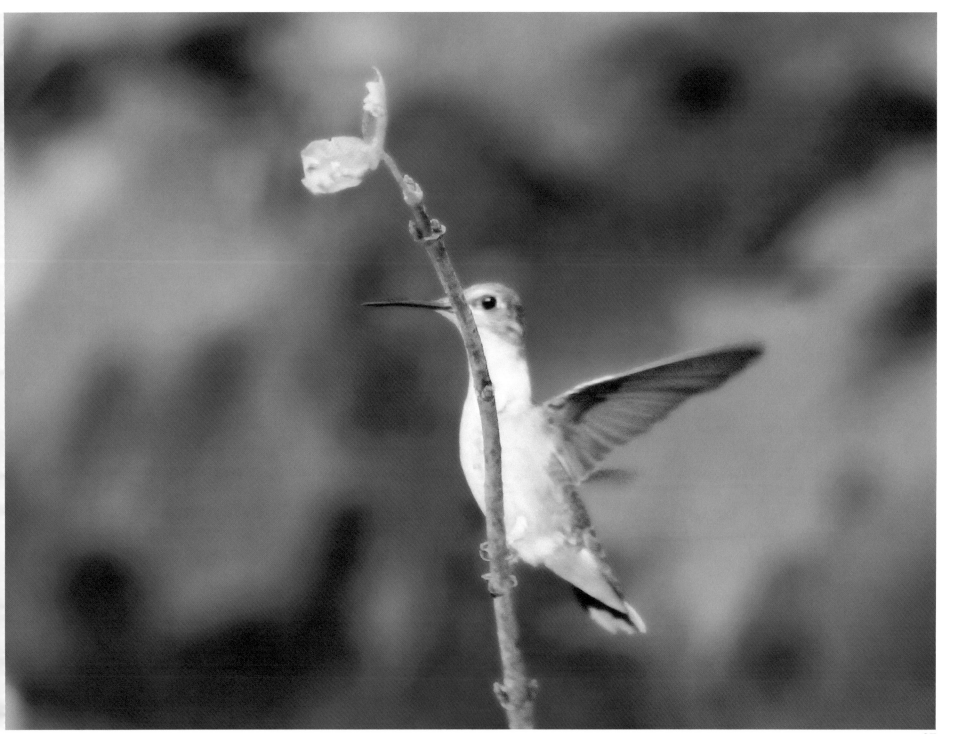

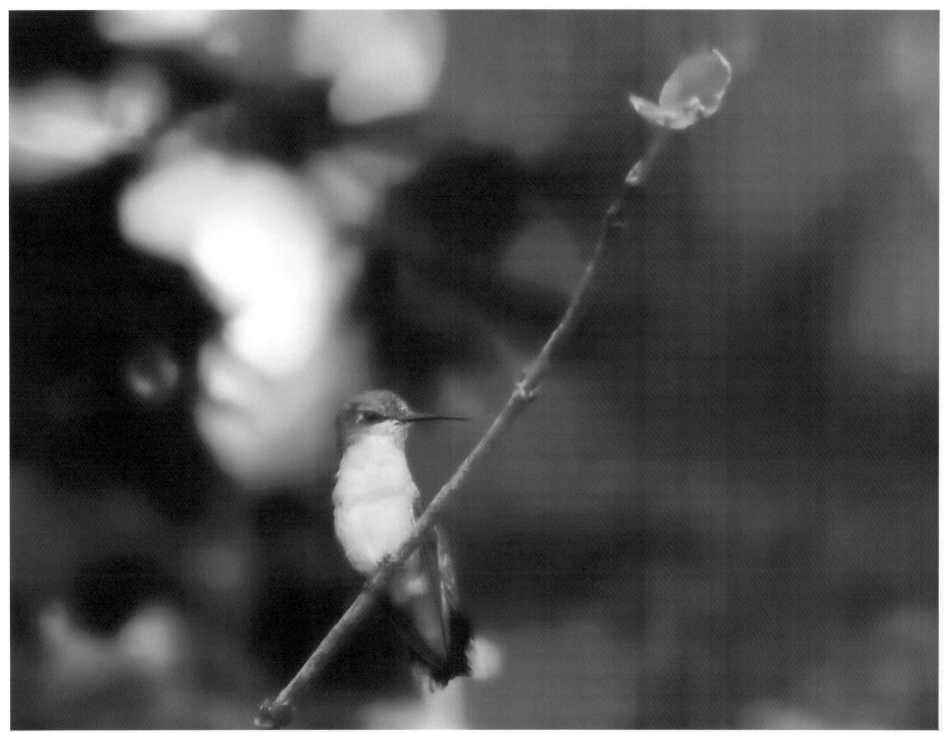

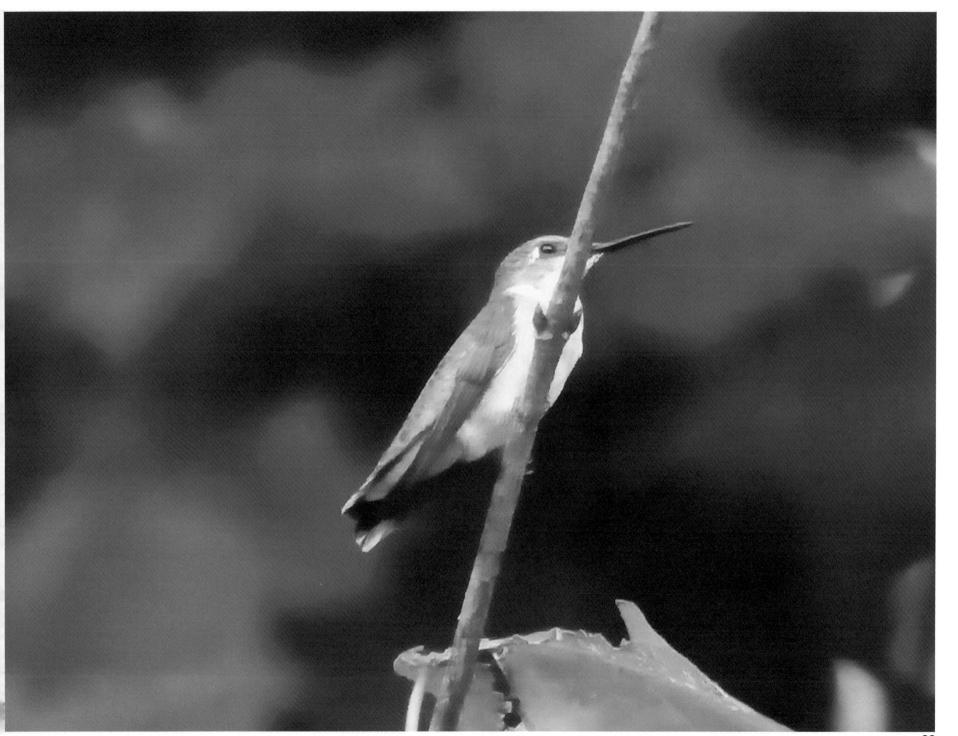

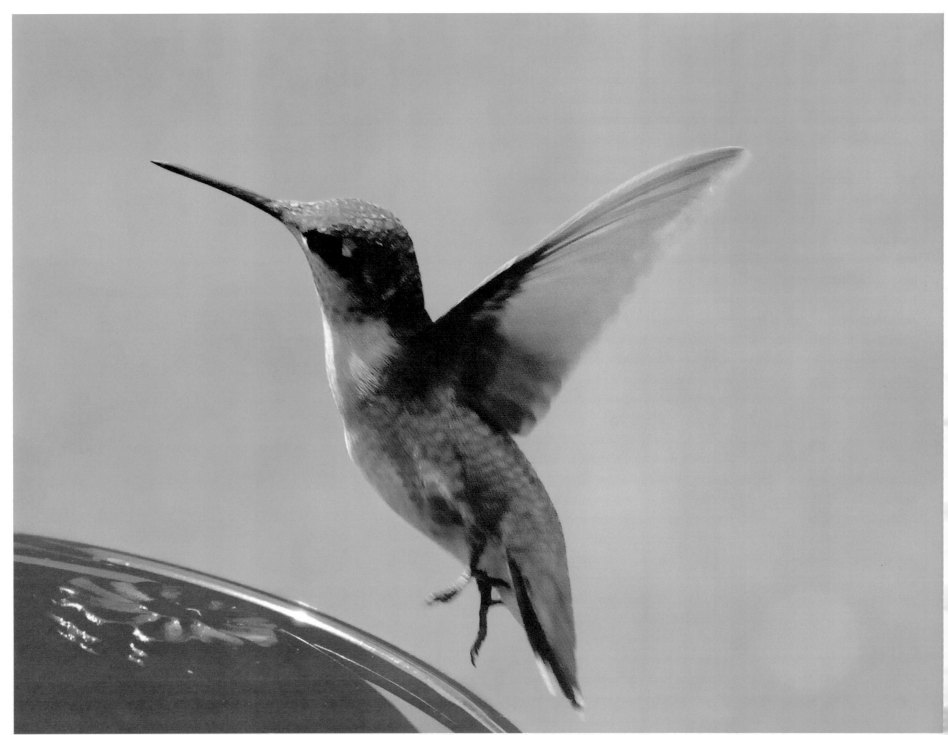

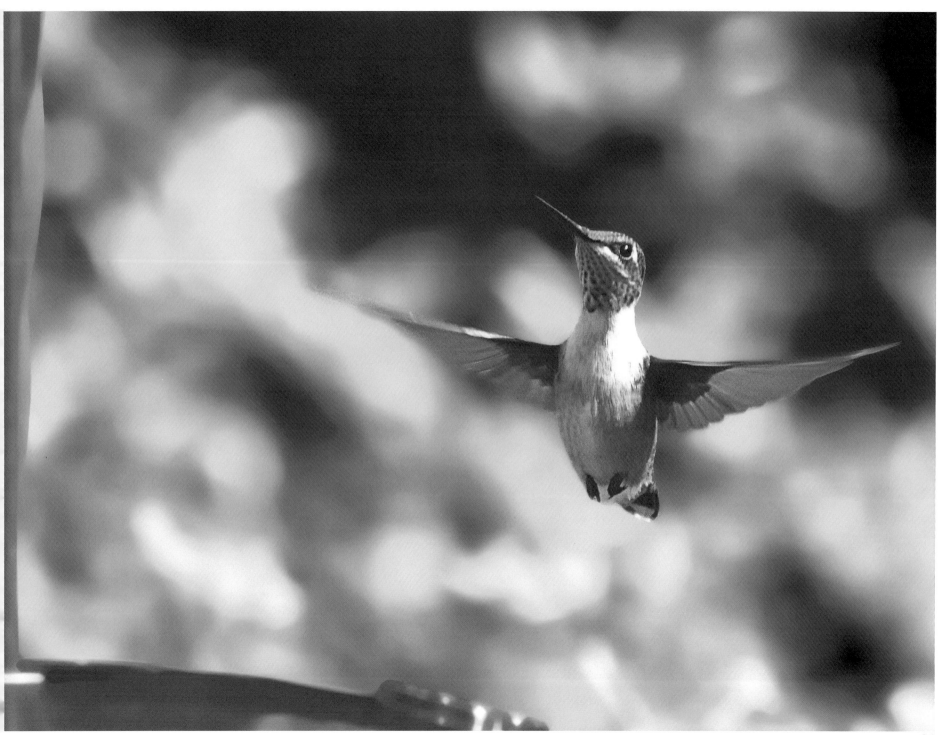

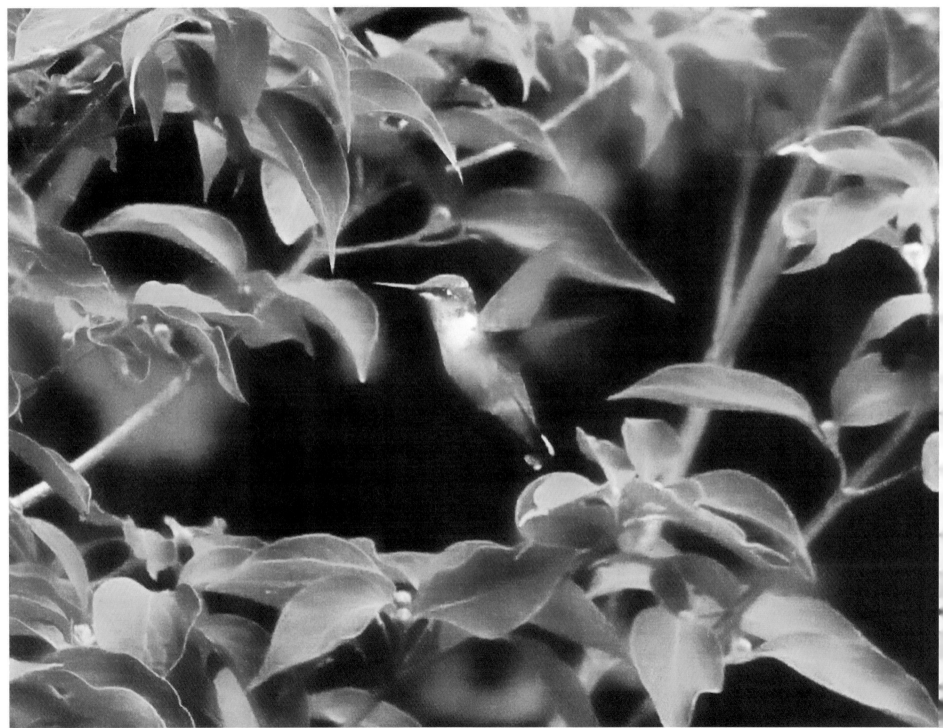